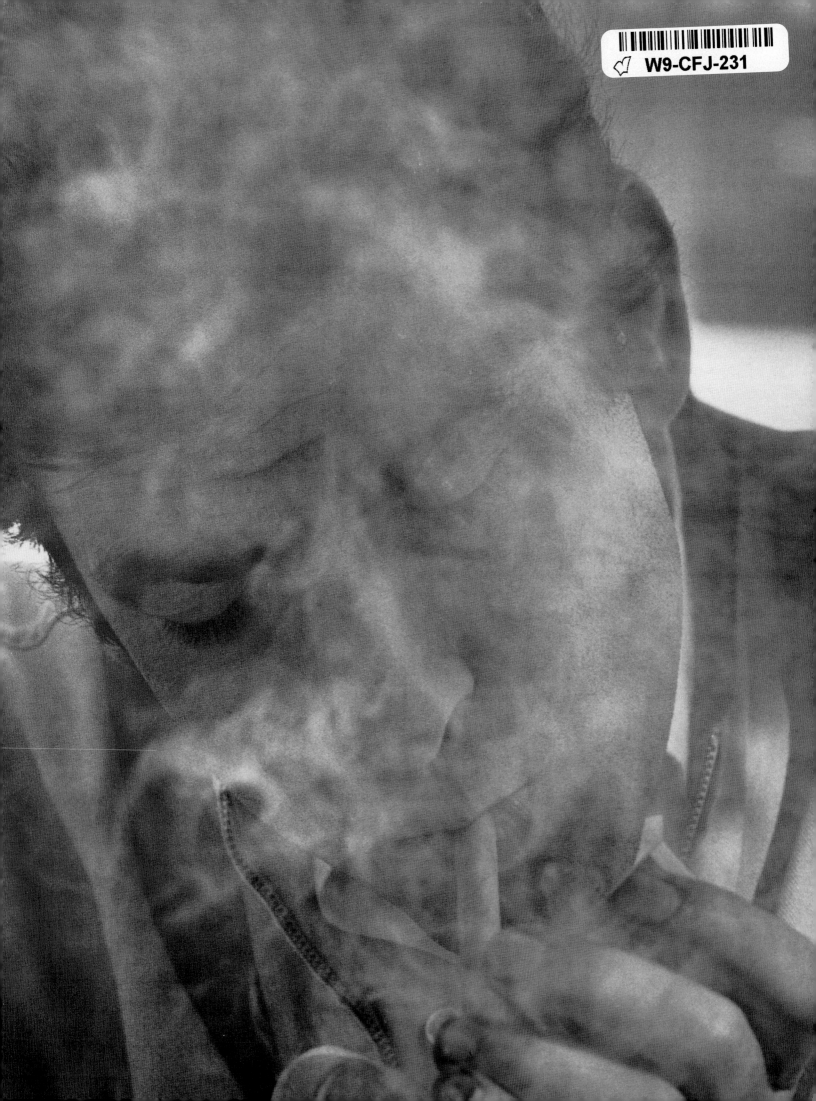

This publication was prepared in conjunction with the
exhibition John Altoon. Co-curated by Andrea Hales
and Hugh M. Davies, it was presented at the Museum
of Contemporary Art, San Diego, from December 7,
1997 through March 11, 1998. This exhibition and
publication are made possible, in part, by the generosity
of Elizabeth and L.J. Cella, AFFMA (Arpa Foundation
for Film, Music & Art), and a major grant from the
National Endowment for the Arts, a federal agency.

Memories of John by Robert Creeley, reprinted from
The Collected Essays of Robert Creeley,
University of California Press © 1989.
Permission to reprint granted on behalf of
the Regents of the University of California.

Designed by Richard Burritt, Burritt Design
Printed and bound in the United States by
Precision Litho, San Diego.

Library of Congress Catalogue Card Number
97-69897
ISBN 0-934418-51-9

Available through D.A.P/ Distributed Art Publishers
155 Avenue of the Americas, Second Floor
New York, N.Y. 10013-1507
tel: (212) 627-1999
fax: (212) 627-9484

Cover image: Untitled (Trip Series), 1959 (detail)
Collection Museum of Contemporary Art, San Diego
Gift of Ruth and Murray Gribin

Frontispiece: John Altoon, 1964 (detail)
Photograph by Dennis Hopper.

CONTENTS

FOREWORD

HUGH M. DAVIES

For more than thirty years, the Museum of Contemporary Art, San Diego has embraced a policy of exhibiting the work of promising emerging artists and promoting mid-career artists who deserve wider recognition. John Altoon's untimely death in 1969 at the age of forty-three no doubt partly accounts for the undeserved obscurity in which he and his considerable oeuvre have languished for far too long. While he died almost thirty years ago, his young age and the lack of serious consideration his work has received in the interim make him a suitable subject for a mid-career survey exhibition, as it were, rather than a retrospective.

Altoon, a native of Los Angeles, was a painter of enormous importance in Southern California in the late 1950s and early 1960s. He was the senior artistic presence in the legendary Ferus Gallery, that seminal institution which nurtured such important contemporary artists as Robert Irwin, Ed Kienholz, Billy Al Bengston, Ed Moses, Craig Kauffman and later Larry Bell and Ed Ruscha. Altoon was L.A.'s Abstract Expressionist, its gestural painter who, through both his work and lifestyle, served as the indispensable role model for the generation of artists who took art in California beyond New York. Psychologically troubled like Van Gogh and as macho with art and women as Pollock, John Altoon frightened his friends with fits of destructive behavior when neither their canvases nor his were safe from slashing outbursts. He once joked that if he ever made it rich, he'd buy his own shock therapy machine.

A roguish, unselfconsciously disheveled figure, unshaven with a permanently drooping mustache and cigarette, he obtained without affect a unique bohemian stature among his peers. As cool and devil-may-care as the Ferus boys tried to appear in photos, the swarthy Altoon couldn't help it. Yet his wild persona was matched by an almost old-fashioned commitment to the rigors of abstract painting, as if he felt his brilliant figurative drawing escapades were too facile and unworthy of a serious artist. Ironically, these Rabelaisian indulgences, informed equally by advertising and erotica, may yet constitute his most original and relevant artistic legacy. Rather than an innovator in his painting, Altoon was more a consolidator. In his best canvases, he brought to the organic shapes and gestural vocabulary of de Kooning and Gorky a lyrically sunny and seductive palette that, in chroma, matched the liberation of the old East Coast painters' marks, while providing a new context of specifically California color.

We are proud that in 1960 this museum (then called The Art Center in La Jolla and directed by Donald J. Brewer) had the foresight to invite John Altoon to serve as an artist-in-residence and to present a solo exhibition of his work. At that time, MCA acquired several paintings and works on paper, and over the years has increased Altoon holdings to more that forty pieces. A significant artist's oeuvre is inevitably reassessed by every generation, and recently-renewed interest in abstraction, painting and even beauty combine to make this the right time and place to review John Altoon's contribution.

No one would deny that the very eccentricities that led to his demise were an integral part of the mythical Altoon. Indeed, the legend of his persona continues to some degree to eclipse the radiance of his considerable artistic achievement. Finally, while sober hindsight confirms that Altoon's behavior was at times diabolical, with this exhibition we can see for ourselves that – to quote the words of more than one of his contemporaries – "...he drew like an angel."

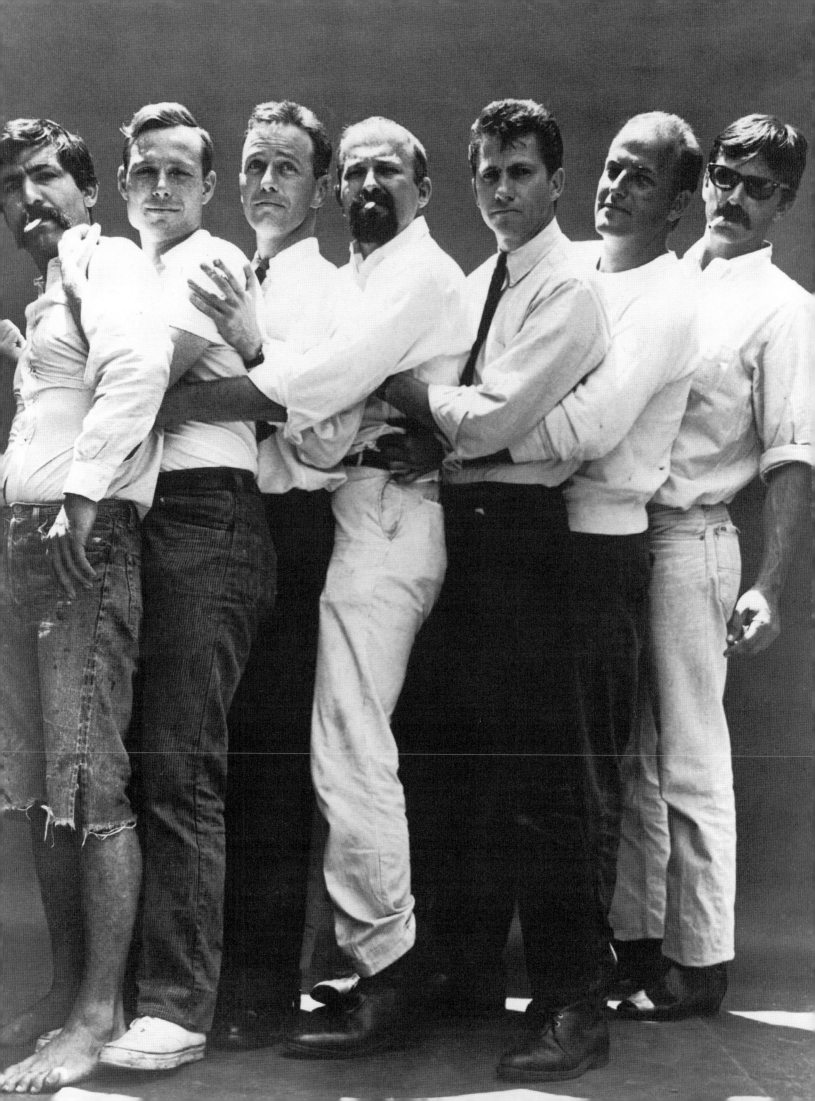

CHRONOLOGY OF AN ARTIST

ANDREA HALES

In 1969, at the age of forty-three, John Altoon died of a massive heart attack. During his relatively short life, he lived with intensity and passion, and accomplished a great deal as an artist, in the process influencing the course of art in Southern California both before and after his death. Even the earliest examples of Altoon's student work from the late 1940s show his fluid and facile line in figurative ink drawings. One can follow his talent and growing interest in Abstract Expressionism through the 1950s, and see it emerge into the more idiosyncratic compositions of biomorphic shapes in the early 1960s. Increasingly surreal forms dominated Altoon's compositions by the mid-1960s. The variety of his painting styles over the last ten years of his life is somewhat confounding, yet it indicates the artist's need to express a personal vision. A prolific and gifted draftsperson, Altoon made both figurative and abstract drawings throughout his life. These compositions, often with erotic subject matter, conveyed a sense of emotive release through their spontaneity and often presaged a new direction in his painting.

This exhibition traces John Altoon's search for expression for both a stylistic voice and a comfortable medium. During that search, the artist was a central figure in the burgeoning Los Angeles art community beginning in the late 1950s, and his presence was vital. Friends and colleagues, especially those associated with the Ferus Gallery, still recognize and cite Altoon as

Friends and colleagues, especially those associated with the Ferus Gallery, still recognize and cite Altoon as an important influence in their own development.

an important influence in their own development. Although no one would contest that Los Angeles occupies an important place in the art world today, this was not true in the late 1950s. Rather, this was the formative period for the visual arts in Los Angeles and became the foundation of what is now an internationally recognized community.

John Altoon's parents were first-generation Armenian immigrants who met and married in California and became part of the large Armenian community in Los Angeles. On November 5, 1925, their son John was born. His father worked in a bakery while his mother had trained to become a teacher. Altoon attended Dorsey High School[1] in central Los Angeles, where his facility as an artist first emerged. His artistic talents won him a scholarship to Otis Art Institute in Los Angeles, and he left high school to attend. But, dissatisfied, he soon returned to high school to complete his degree.

In the early 1940s, Altoon joined the U.S. Navy as a radar technician and served in the Pacific during World War II. Along with millions of veterans, he returned to Los Angeles at the end of the war and in 1947 enrolled again at Otis Art Institute with the help of the G.I. Bill. In 1949, he transferred to Art Center School in Los Angeles, where he studied illustration. A self-portrait from this period shows an earnest young man standing in front of the easel amidst nude figure studies (p. 18). Soon tiring of Art Center's emphasis on training for a commercial career in art, he transferred to Chouinard Art Institute, also in Los Angeles. At Chouinard, Altoon's drawing ability was recognized and encouraged and, in 1950, he won an award for his work.[2] He soon moved north to Santa Barbara to pursue his art full-time. There, he shared a studio with a friend from Dorsey High School, Donald Brewer, who nine years later, in 1959, became the director of what was then called the Art Center in La Jolla (now the Museum of Contemporary Art, San Diego). In 1951, with the help of Brewer, Altoon had his first one-person exhibition at the Santa Barbara Museum of Art.

Buoyed by his modest success, Altoon moved to New York in 1950, considered in the postwar period to be the center of the international art world. In New York, he proceeded to work both in commercial illustration and fine art. Supporting himself through advertising jobs, Altoon continued his search for a personal style of expression. His figurative semi-abstractions were included in several group exhibitions, and in 1953, he won the Emily Lowe Award, with its attendant prize of $600, and had his first one-person exhibition at the Artists' Gallery.[3] Having sold several paintings and received encouraging reviews,[4] the twenty-eight year old Altoon continued living in New York for another year and had a one-person exhibition at the Ganso Gallery in 1954. Becoming restless, however, he left for Europe where he spent six months, mostly in Spain. While in Mallorca, he met up with poet Robert Creeley, someone he knew casually in New York but who became a lifelong friend.[5] For a period, they were part of a small American artists' colony living and working on the island. Altoon was very productive here, continuing his foray into abstract compositions using new materials. At the same time, however, he was experiencing severe depressions and periods of extreme psychosis, which eventually prompted his return to Los Angeles in 1956.

Back in California, Altoon took a position teaching drawing at Art Center,[6] and became acquainted with Edward Kienholz and Walter Hopps, founders of the Ferus Gallery, who included him in Ferus's opening exhibition in 1957.[7] That show introduced Abstract Expressionism to Southern California and, in addition to a handful of Los Angeles artists, featured several artists active in the San Francisco Bay Area, including Clyfford Still and Richard Diebenkorn, who had been working in this style since the late 1940s. Many in the Ferus group looked to Bay Area artists such as these, as well as to the painters of the New York School of Abstract Expressionism.

John Altoon exhibited frequently at Ferus Gallery from 1957 through 1961, and less frequently from 1961 until 1963.[8] He was an important and dominant figure among the Ferus group, and his technical facility, both in painting and in drawing, was

Between 1958 and 1961, Altoon worked primarily in the Abstract Expressionist style, experimenting freely with techniques and materials and seeking his own form of expression.

impressive. Irving Blum, who in 1958 took Kienholz's place as a partner in Ferus Gallery, states that "if the gallery was closest in spirit to a single person, that person was John Altoon – dearly loved, defiant, romantic, highly ambitious – and slightly mad."[9] Blum describes Altoon as "an extraordinary figure"... "incredibly gifted and absolutely brilliant."[10]

Larry Bell says that, of the Ferus group of artists, Altoon was the "smartest guy who totally trusted his intuition."[11] Bell also calls him "one of the funniest people I have ever met."[12] Yet he describes an incident that underscores Altoon's mental illness: "About 1960, I helped John move into a studio next-door to me on Marine Street in Venice. [Billy Al] Bengston told me I would live to regret it. In fact I did. At one point John went off the deep end and decided that the best thing for me would be if he destroyed all my work. I kept the doors locked, and he decided to destroy all *his* work instead, and proceeded to do so. It was not a funny moment, as John was possessed by real demons, and it took all the skill of a very kind man named Milton Wexler to help John unwind from this. He probably gave John an extra seven years of life."[13] Ken Price, who said John Altoon's work had "moments of sublime," felt Altoon was a real force as a person. In fact, after his death, Price felt the loss so much it was one of the reasons he says he moved to New Mexico. For him, Los Angeles was not the same without the presence of John Altoon.[14]

Between 1958 and 1961, Altoon worked primarily in the Abstract Expressionist style, experimenting freely with techniques and materials and seeking his own form of expression. In *Fay's Christmas Painting*, 1958 (p. 20), named for his first wife, actress Fay Spain, areas are worked and reworked yet still maintain a sense of spontaneity by the use of calligraphic lines, which also define different planes within the painting. This and other earlier works glow with vivid colors and unbridled enthusiasm. In paintings from 1959, Altoon employed more somber, earth-tone colors such as ochre, tan and beige, often laid over a fleshy pink-peach ground, as in two untitled paintings (p. 21, 22). These floating, overlaying shapes – completely abstract now – are at first soft, undefined areas of color, as in his 1958 works, but become more geometric and contained, anticipating Altoon's next development. In both canvases, blue and a rusty-red highlight the compositions like a jazz key note. Altoon was included in the competitive annual exhibition at the Los Angeles County Museum for four years beginning in 1958, another signal of his growing recognition and status within the local arts community.[15]

In early 1960, Altoon would have seen the exhibition "14 New York Artists" at Ferus Gallery.[16] It is easy to understand how he was influenced by artists such as Willem de Kooning and Philip Guston for their wide, brushy style; Joan Mitchell and Arshile Gorky for their use of thin calligraphic line; James Brooks, Franz Kline, Robert Motherwell and Jackson Pollock for their gestural marks; and Hans Hoffman and Mark Rothko for the use of floating areas of color. But it was elements of de Kooning, Guston and Gorky's painting that Altoon absorbed most completely and made his own over time. Evidence of de Kooning's influence in covering the entire canvas with shapes and forms is clearly seen in

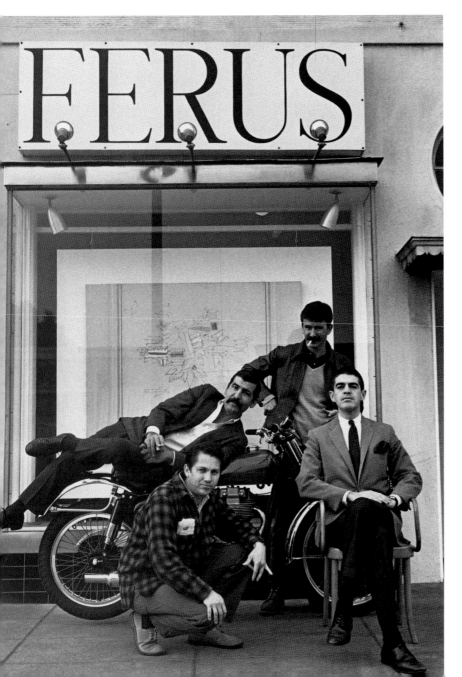

CLOCKWISE, FROM TOP LEFT: JOHN ALTOON, BILLY AL BENGSTON, IRVING BLUM AND ED MOSES, IN FRONT OF FERUS GALLERY, 1959. PHOTOGRAPH BY WILLIAM CLAXTON.

a painting included in the 1959 annual Los Angeles County Museum exhibition, *Untitled (Trip #2)*, 1959 (p. 23), and in *Untitled*, circa 1960, where brushy, de Kooning-like triangular and sail-shaped elements dominate overall. Like Gorky, de Kooning's images of fantastic organisms derive from human anatomy, and his brushstrokes often suggest anatomical elements, as do Altoon's. Gesture painting, taken to its highest level by Willem de Kooning, conveyed a sense of the artist's life experiences and of his creative struggles. This freedom to release emotions through the use of paint must have appealed greatly to Altoon, enmeshed as he was with his increasing mental instability.

Altoon's strong, wide brush strokes consume the canvas in his *Trip Series* of 1959 (p. 24, 25), and are reminiscent of Philip Guston's compositional device of brushy parallel strokes in concentrated areas. Like Guston's work from the 1950s, the intensity of the brush strokes falls away around the perimeter of the canvases – especially in the *Trip Series* – concentrating on a more centralized composition.

Altoon's bond with Arshile Gorky would prove to be even closer than that with de Kooning, both in painting style and personal

In Venice . . . Altoon began his *Ocean Park* series consisting of brightly colored floating, biomorphic shapes and forms on empty, white-primed canvases.

history. Gorky, born in Armenia, immigrated to the United States in 1920 as a teenager. Altoon identified closely with the older artist with whom he shared Armenian ancestry.[17] Like him, Altoon was a formidable draftsperson and the sureness, lucidity, and inclusion of line in Gorky's paintings were clearly an influence on his work. In the 1940s, Gorky realized that the emotional confusions that he released in privately-kept drawings were actually the essence of his personal statement.[18] Given Altoon's natural drawing ability, he may have also realized that his drawings were the core of his emotional release. He undoubtedly also identified with Gorky's mental state; the latter artist led a troubled life and, in 1948, at the age of forty-four, committed suicide.

Despite his emotional problems, John Altoon's career continued to flourish. In late 1960, he was an artist-in-residence at the Art Center in La Jolla where he taught art classes and had a one-person exhibition.[19] Concurrently, he was also represented in a group exhibition at the Art Center by one painting, *Untitled*, 1960 (p. 26), that shows a shift in styles.[20] Here, Altoon clarifies the composition by emptying the canvas and featuring more of the white ground. In the early 1960s, he moved to a new studio in Venice, where many L.A. artists had established studios. Rent was cheap for large, open spaces, and a close-knit, sometimes competitive community of young, avant-garde artists found kinship in challenging the status quo. It was in Venice that Altoon began his *Ocean Park* series consisting of brightly colored floating, biomorphic shapes and forms on empty, white-primed canvases, and where he began to find his distinctive voice as an artist.[21]

In the *Ocean Park* series, there is a nonsensical yet buoyant quality, indicating Altoon's mental state at the time. The *Ocean Park* series proved to be very popular, and the work traveled in various exhibitions in 1962 and 1963.[22] During 1963, Altoon

experienced a period of extreme mental distress and was hospitalized briefly at Camarillo State Hospital north of Los Angeles. He was diagnosed as schizophrenic and was treated through shock therapy, medications and psychotherapy by Dr. Milton Wexler, a well-known Los Angeles psychiatrist who treated many in the creative community. Despite his illness, Altoon also began teaching at Chouinard in 1963, where he made a number of figurative drawings.

Occasionally, Altoon's objects may be read literally – a fish or a chair – but more often than not, the biomorphic forms became personal symbols. This use of personal symbolism, paralleled in Gorky's work, stemmed from Altoon's associations with automatism and free association and his intensive psychotherapy – for long periods on a daily basis – under the care of Dr. Wexler. Forms which often appear in Altoon's work through the end of his life and in all media – paintings, drawings and prints – are the clover shape attached to a stem symbolizing male genitalia (p. 27), the floating clam-like forms symbolizing female genitalia (p. 42), and the device of inserting yawning windows within forms to reveal Altoon's private sexual fantasies (p. 39, 46).

In reaction to Abstract Expressionism, Pop Art came into vogue and by the late 1950s and early 1960s, many Los Angeles artists including Billy Al Bengston, Joe Goode, and Edward Ruscha were making common, everyday objects the focus of their art. Andy Warhol, who like Altoon also worked as a commercial artist, exhibited his *32 Cans of Campbell Soup* at Ferus Gallery in 1962. Around this time, Altoon began to link his interest in figure drawing with his background in illustration and advertising by creating satiric advertisements (p. 30). But instead of focusing on the common object as the subject of these works, Altoon used the objects as props with which to express his fascination with sex and women.

He continued making drawings of the nude female form throughout his career, yet Altoon's images of nude women are not renditions of beauty in the classical tradition. Rather they seem brazen or even lascivious. Altoon's admiration of de Kooning and Pablo Picasso and their depictions of women liberated Altoon.[23] His obsession with sex, as well as his ambivalent feelings about women, began to appear in illustration form, and his overt satires on modern advertising theory (that "sex sells the product") became more fanciful and imaginative in these later years, as in *Untitled (Colgate)*, circa 1964-66 (p. 39).[24] These satiric drawings, no doubt influenced by the artist's intermittent jobs in advertising, were made mainly on 30 x 40 inch or 40 x 60 inch illustration boards.

Altoon was especially prolific between 1966 and 1968 when his drawings became much more spontaneous. The works from this late period often had fantastical themes and during the 1960s "hippie" era that espoused free love, they were probably deemed acceptable, even light and erotic. Yet, attitudes have changed in the intervening thirty years with the advent of the women's movement. And although modern culture still uses the female body – particularly in advertising and through the media – as an object of desire, to be controlled and possessed, many now find this type of depiction offensive and degrading.[25]

One of the recurring themes in these often fantastical works is that of *vanitas*, or the image of a woman looking at herself in a

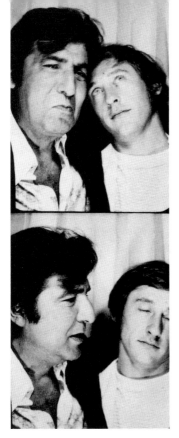

mirror. *Vanitas*, which literally means "emptiness" in Latin, is a common theme throughout the history of art.[26] Two Altoon examples from the 1960s show a woman using a hand mirror. In *Untitled (Woman with Mirror)*, circa 1964, a woman with mirror is accompanied by two older nude males. Later, there is a much more explicit drawing from 1967 of a kneeling woman peering intently into a hand mirror (p. 47). Fondling the woman from behind is an ape, and, although the reflection in the mirror shows a young woman, her facial profile resembles the ape. Vanity, one of the minor vices in secular allegory, was often represented during the Renaissance as a naked woman, seated or reclining, attending to her hair with a comb and mirror.[27] Altoon had no doubt seen Picasso's images on the same theme. Yet he takes this theme and alters it slightly: in each of these drawings, the women stare blankly at the mirror while being mauled by males, placing emphasis on the female's vulnerability and passivity.

A technique Altoon appropriated from his commercial art work that became his most identifying stylistic feature, was the use of an airbrush, with which he began experimenting in late 1964.[28] This device, a pencil-like applicator attached to a compressor, allowed the artist to define specific areas with a fine mist of color that resulted in a soft, fantastic quality reminiscent of earlier work of the Surrealists. Yet, Altoon's imagery was uniquely his own. Strange, organic shapes outlined in ink are given depth and color, their forms floating either on the white of the illustration board (usually positioned vertically) or sometimes against a background grid of airbrushed dots. Like the imagery in the *Ocean Park* series, the compositional elements in the work from 1964 to early 1967 stem from the artist's imagination and

A technique Altoon appropriated from his commercial art work that became his most identifying stylistic feature, was the use of an airbrush.

complex psyche, and are very expressive. Altoon made hundreds of drawings with the airbrush, beginning with the *Hyperion, Sawtelle* and *Miramar* series of 1964, continuing with the *Seaview Terrace* and *Sunset* series of 1965, and finally with the abundant *Harper* series from early 1966 to 1967.

Also in 1964, Altoon began transferring to his paintings on canvas the look he achieved on board with the use of the airbrush. In the *Hyperion* and *Sunset* series, 1964-65, he clarified and tightened his compositions. The essentially flat configurations of the earlier *Ocean Park* series, where organic shapes were clustered and yet floated over the entire white canvas, became simplified with centralized compositions in the later series. This

was achieved by selecting one or two biomorphic shapes and centrally isolating them against a now deeply-colored ground (p. 35-37). These paintings from the *Hyperion* and *Sunset* series, with their beautifully executed and luscious areas of color and brushwork, are the culmination of years of Altoon's search for his own form of expression.

By 1965, the artist had clearly hit his stride and reached a maturation of style.[29] The continuing help of Dr. Wexler had given him relief from his mental illness and, that spring, he met Roberta "Babs" Lunine, who was to become his second wife. Babs had an enormously calming and stabilizing influence on him from that time until his death. He had found his own iconography, style and expression, and he now put his painting aside to make an abundant number of spontaneous ink drawings. One can only speculate why Altoon concentrated on the explicit sexual drawings at this time, but perhaps having satisfied his search for abstract expression, he returned to his more immediate talent, drawing. He was encouraged to create his bawdy compositions by his Los Angeles dealer, David Stuart, with whom Altoon showed from 1964 until his death.[30]

The *Princess and the Frog* series, 1968, and others such as the *Cowboy and Indian* series, 1968, are usually lighthearted in their sexual depictions, but there are examples which show a more sadistic side to the artist. *Shoot the Baby*, 1966, a cynical scene of a male and female both pointing guns at a baby, shows Altoon's perverse streak as well as his diversity of line.[31] Altoon drew the figure in a variety of styles, yet the quality of his line was always sure and spontaneous.

During 1966, he also made a suite of ten color lithographs entitled *About Women* at Gemini Ltd. in Los Angeles, working with master printer Ken Tyler (p. 40-41).[32] Accompanied by three poems by his friend Robert Creeley (entitled *Anger*, *The Woman*, and *Distance*), these boldly colored compositions of biomorphic shapes – mainly oriented in square formats – isolate elements of Altoon's personal shorthand. The meaning of his iconography remains obscure, yet phallic references abound, often in seashore imagery reminiscent of his popular *Ocean Park* series. Additionally, simple mandala-shaped graphic designs appear for the first time.[33]

Altoon painted fewer canvases between 1966 and 1968, but there are examples of paintings from late 1968 and early 1969 when he began making shaped canvases. According to the artist's widow, the idea of making shaped canvases came from examining matches in a matchbook, and Altoon embraced the challenge of attempting to depict foreshortening.[34] He made three shaped canvases at this time, although two are not fully resolved. In the third, the three panels abut one another and there is color at the edges.

Many artists were experimenting with these concepts at the time. The use of color at the edges of paintings is reminiscent of paintings made in 1966-68 by fellow Los Angeles artist Sam Francis; shaped canvases were being made by Frank Stella; and shaped Fiberglas paintings were created by another L.A. artist, Ronald Davis. As Altoon had experimented earlier with Abstract Expressionism in order to find a suitable mode of expression, again he followed his intuition and experimented with new directions and techniques – here a cooler, more intellectual

direction compared to the action painting that was perhaps more obviously suited to his nature.

The existence of these shaped canvases indicates Altoon was concerned with current trends. His status as an artist had declined by the mid-1960s – both in terms of the prestige of his gallery and in the popularity of his work – and he must have been wondering what he could do to boost his reputation. Altoon had been at the crest of a cutting edge, a leading figure of the prestigious Ferus Gallery in the late 1950s and early 1960s, and was influential to a number of artists at that time. But by the mid-1960s, he was showing at the less notable David Stuart Galleries, and his style of painting and form of expression were no longer in fashion. Many of his fellow Ferus artists had moved in different directions. Several were working in more minimal, reductive styles, while others moved toward the "finish fetish" or "Cool School" esthetic for which Southern California became renowned. Although Altoon had developed his own unique voice, perhaps he felt he needed to continue his search for expression or refine his style to remain at the forefront of the art community. Ironically, he seemed more self-conscious now that his mental problems were apparently stabilizing.

Altoon continued making drawings during this time and, by 1968, eliminated most of the "figure" in his drawings to concentrate purely on genitalia.[35] In contrast to other series, such

Altoon was larger than life, the exuberant center of a group of artists who were changing the direction of art history.

as *Princess and the Frog* (p. 49), where women and frogs interact in nature, the drawings from this later period often depict disembodied vaginas or hovering penises. Watercolor was delicately added, giving the works a beautiful, soft quality. In one whimsical drawing, penises fry like sausages in a skillet (p. 50), perhaps suggesting Altoon's feelings of emasculation in a period when his influence with the L.A. art community began to wane.

These images of isolated genitalia are among the last works Altoon completed. In January and February of 1968, he had a Fellowship at the Tamarind Lithography Workshop in Los Angeles where he made a series of twenty color lithographs.[36] In these prints, one recognizes Altoon's signature biomorphic imagery and use of bright color, yet the forms are much more structured and blocky. The densely patterned backgrounds are unusual and seem almost baroque. These were shown at David Stuart Galleries in May 1968.[37] Less than a year later, on February 8, 1969, John Altoon was at a party when he experienced severe chest pains. He died soon after of a massive heart attack. It was a shock to his many friends, who saw him as a charismatic, captivating personality, full of life and a fixture in the Los Angeles art scene.

Altoon is remembered today as a central figure in that crucial period when Los Angeles first established itself as a vital art community, a period that led to the city's position today as a leader in the international art world. In looking back at that time, Altoon's varied and diverse styles of working make him an elusive and enigmatic figure. Yet consistent in his search for expression was his emotional release evident in the spontaneous drawings which often led to new directions in painting. Altoon's voracious exuberance for sex, and his fresh and freely expressive outpourings in the form of drawings, anticipated the contemporary focus on the body and sexuality. Today's art has, of course, been influenced by layers of contemporary society since the 1960s, including the changing roles of men and women, the devastation of AIDS, and much of society's obsession with physical health and the perfection of the human body. Yet undoubtedly, the notorious and raw sexuality of the late works of John Altoon presages this current trend, setting the stage for today's artists who are pushing the boundaries of propriety and taste.

In the late 1950s and the early 1960s, John Altoon was larger than life, the exuberant center of a group of artists who were changing the direction of art history. As Billy Al Bengston said, "He influenced all of us – more as a person than in any other way."[38] His captivating and operatic personality, his complex and volatile mood swings, his generosity and his excesses, and – most of all – his need to make art and the art itself are all part of the Altoon legacy.

JOHN ALTOON: PERSONAL RECOLLECTIONS

Dr. Milton Wexler

They told me they had literally carried John Altoon to my office. As I looked at John in my waiting room and invited him to come into my consulting room, I thought that perhaps the group of artists who made that claim were exaggerating somewhat. John was clearly physically powerful and it would have taken a squadron of giants to get him to the office of a psychoanalyst against his will. Even his quiet entrance into my consulting room meant a degree of acquiescence that gave me an important clue about how to proceed. I already knew that John had gone to La Cienega Boulevard in Los Angeles, the street where many art galleries were located, and had threatened to destroy every last art production on display in every gallery. The beautiful and delicate boxes created by Larry Bell were on exhibition and it would have taken John barely thirty seconds to wipe out years of dedicated and creative work. Panic had seized the art community, and the painters in my waiting room who had grabbed John and brought him to my office knew that he had gone mad. They also knew that I had treated schizophrenics. I was to be their savior.

From John's half-willingness to come to my office as well as his ready willingness to come into my consulting room, I felt safe in challenging him with very strong language. At first, John looked puzzled and then faintly amused. He explained that God had sent him a message to destroy all of the art on the face of the earth. Then, he was to teach little children how to create art that was genuinely fine and noble. His artist friends in the waiting room had begged him to come and talk it over with me. He knew he could persuade me he was on some God-given course. I would give him permission to carry out God's will. It seemed to me that John had slipped over the edge of the precipice but had not fallen all the way. He was clinging to some outcropping of doubt. He seemed willing to negotiate. After hours of discussion, I told him I would think about this mission. In the meantime, he must return to his studio, where he also lived, and must promise to come to see me daily. We must reach some understanding of the heavenly will. John's quick assent to this convinced me that his delusion was on shaky ground, that for the time being La Cienega was safe. Down the line, in the long haul, I knew I would be dealing with some agonizing emotional state that had driven John Altoon to his grandiose delusion.

To everyone's surprise, John kept his word. For years I saw John on a daily basis, often for many hours at a time. Prior to 1965, he had mild slips into delusional states, either of a grandiose or paranoid nature. Only once did the paranoia become so severe that I was forced to hospitalize him. This was in 1963, when he refused to come see me, when he locked himself away in his studio, when I thought he was without food, and through the locked door, he suggested to me that others were intent on stealing his art. I shouted orders that he must agree to go to the state hospital in Camarillo. To my utter surprise, he was once again agreeable and he remained at Camarillo for a number of weeks, after which he promised he would not shut himself off again. I immediately signed him out of the hospital and we had a glorious time over hamburgers and beer on the way back to Los Angeles.

Often John moved through life as if he were on stage at the Metropolitan. He didn't ask my secretary for a cup of coffee. His booming voice sang an aria. In one moment, he was a playful child, in the next, an angry adolescent, and in the next, a thoughtful observer, but I never knew until after his death that John was a great poet. When John died, his wife, Babs, brought me his notebooks filled with wonderful poetry. I read one of those poems at his graveside as his body was being lowered in his coffin. It spoke of death with both passion and awe. No wonder the poet Robert Creeley was his close, personal friend. Over the years, the mad, agonized, tortured artist did reach some level of contentment. Such friends as Ed Moses, Billy Al Bengston, Kenny Price, Craig Kauffman, Frank Gehry, and Larry Bell contributed much to this outcome. Above all, his wife, Babs Altoon, did wonders in settling his life and providing him with a security out of which came his most creative work.

One Friday evening, when I was at home alone, I received a telephone call from John. "Milton," he said in his loudest operatic voice, "I am going to a party. I'm a very happy man. I owe much to you. I'm going to have a wonderful time. I'm calling to say thank you." "John," I exclaimed, "Nobody ever does that. I'm speechless. I can't believe it. Be happy and enjoy. I love you." Two hours later, I received a telephone call. The voice was filled with grief and panic. "John Altoon is dead. He didn't feel well at the party. He died while being examined at the home of Dr. Asher. Come quickly." I dashed there. There was John propped up on a chair in the living room, sitting as if merely asleep. His face was between white and yellow. His eyes were shut as if somnolent. I went to pieces inside. For the moment, I couldn't grasp whether he was alive or dead. I couldn't help the thought that crossed my mind – even in death he is theatrical.

You've got to be up there somewhere, John. At the age of eighty-nine, I should be joining you pretty soon. No doubt you'll be painting lush figures of angels. With your forthrightness, courage and wit, you may have persuaded God to sit for a portrait. If God happens to be a he, I sure hope you'll make him look just a touch like me. Just kidding, John. You know, just like old times.

JOHN ALTOON RECONSIDERED

PETER SELZ

Everyone who knew John Altoon speaks about his captivating personality: a charismatic man with a laugh in his voice. His handsome features and generous, outgoing personality charmed Hollywood actresses, Armenian rug dealers, art collectors, kids on the street, and his dog, Man (named after Ray). Altoon was a magnetic presence at the Ferus Gallery, that first hub of vanguard artistic activity in Los Angeles. His exhibitions at Ferus met with critical praise, and, in the early 1960s, he was generally recognized as one of the finest artists in Southern California. When he died of a sudden massive heart attack in 1969 at age forty-three, he was buried, according to his wishes, in Forest Lawn, the necropolis of the stars. It was, his erstwhile friend Walter Hopps remembers, "the largest gathering of artists in Southern California I ever expect to see."[1]

Altoonian, the original family name, means "son of gold." Yet this man, as Allan Temko wrote, was also "an artist born under Saturn. He was an *âme maudit*, as damned a soul as any romantic poet."[2] John Altoon experienced a series of almost fatal psychological episodes. Many of his delicately colored paintings, often of erotic encounters, contain hallucinatory images and are imbued with anxiety seasoned with wit.

While studying at the Otis Art Institute (1947-49), at the Art Center School (1949-50), and at Chouinard Art Institute (1950), he became a highly successful commercial illustrator. A drawing of 1949, *The Artist and Models (Self Portrait)* (p. 18), shows his person looking from behind an easel with his palette on his knee. In this unusual composition, the model supports the back of the canvas, while a smaller naked woman, standing on his palette, points a long brush toward the artist. Various naked people are standing or sitting around in this student work of outlandish fantasy. His talent as a skilled draftsman affected his early success as an illustrator who could make fast ink spot drawings for trade journals, advertisements and jazz albums. He was able to complete twenty to thirty drawings a day on 30 x 40 inch illustration board.

But Altoon was not satisfied with his accomplishments as a commercial artist and wanted to be a "real painter," and, with that in mind, felt the need to go to New York, where he stayed for four years (1951-55). He had come to grips with the big New York painters, with the work of Arshile Gorky, Jackson Pollock, Willem de Kooning, and Franz Kline. In 1953 he had his first solo show at the Artists' Gallery, an early alternative, noncommercial space dedicated to the exhibition of young artists of exceptional talent. The works he showed were basically Cubist paintings of facets of forms, tied together by linear designs. None of these works is preserved, but the poet and critic Barbara Guest noted his facility that "causes him to fall into certain art school clichés."[3] He received an Emily Lowe Foundation award and took off for France and Spain, settling in Mallorca, where he established a friendship with the poet Robert Creeley.

In 1956, following a psychotic break, he returned to Los Angeles and actually started his serious career as painter and draftsman. He still had to deal with serious depressions at times, but he was able to engage in long periods of high productivity. In Los Angeles he came into contact with a group of budding young artists, most of whom were connected to Ferus, and became friends with Robert Irwin, Ed Kienholz, Billy Al Bengston and Richards Ruben, as well as with Peter Voulkos. In Los Angeles there were also frequent exhibitions of the paintings of Hans Burkhardt, whose work was directly related to that of his teacher, Arshile Gorky, and his fellow student, Willem de Kooning, and brought the art of the New York School early on to Southern California. In addition, the young Altoon was exposed to the work of the Abstract Expressionists from the Bay Area, to Hassel Smith, Edward Corbett, Richard Diebenkorn, Sonia Gechtoff, and Jay DeFeo.

Consequently, Altoon's paintings prior to 1960 manifest his comprehension of the new idiom. They are allover field paintings, made of diverse patches of earth color, engaged in interplay between figure and ground. He produced a series of "ribbon paintings" in which the innate draftsman worked with wide brushes that he loaded with paint to slash across the canvas in powerful gestures. At times these heavily textured broad color areas are accented by agitated bright lines of color. The color ribbons may also suddenly change directions in these pictures, which burst with exuberance of artistic freedom. It was for this work that the young artist received the James D. Phelan Award and

JOHN ALTOON IN STUDIO, UNDATED. PHOTOGRAPH BY MALCOLM LUBLINER.

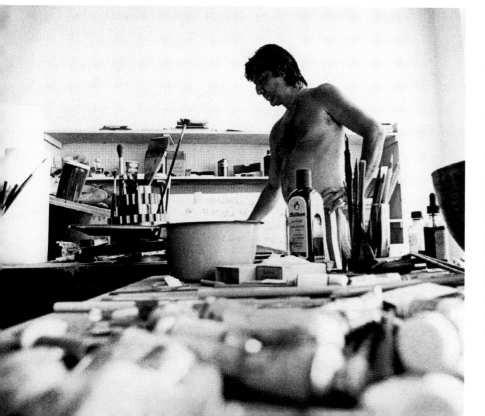

the coveted Junior Council Purchase Prize from the Los Angeles County Museum in 1961.

By the early 1960s, however, he began to feel the Abstract Expressionist mode was in danger of becoming rather academic and he eschewed allover pattern to find his identity as a painter by creating pictures in which organic forms in bright pastel colors are floated on neutral backgrounds. The innovative paintings and drawings he produced during the next few years before his untimely death resembled nothing else that was done during that time and were uniquely Altoons. These singular works seemed no longer suitable in the Ferus stable that had now gained wide acceptance and was no longer the pioneering scene of action. Consequently, Altoon began to exhibit annually (1964-68) at the David Stuart Galleries next door.

Now all kinds of animals, such as birds or caterpillars, become part of his visual vocabulary. We also see all parts of the human anatomy: hearts, kidneys, entrails, and bulbous forms that suggest breasts and buttocks. In these paintings, charged with erotic invention, we also find indications of phalluses, testicles, and vulvae. The first group is named "Ocean Park," after the street where Altoon's studio was located at the time.[4] *Ocean Park #8* (p. 27) comprises four apparently unrelated images. In the right-hand center there is a purple heart with an arrowed stem emerging from it. Other biomorphic forms deriving from the artist's subconscious circulated around this central form. In another canvas of the same year we can make out a black chair with a large phallic shape thrusting to the left, while what could possibly be a red caterpillar and a blue-green bird play in the lower part of the picture. Some of these biomorphic forms recall Gorky's inventions, often based on human forms, allusions to sexual organs and to flowers and animals. There is no doubt that the young California Armenian painter had great admiration for the great earlier Armenian-American artist, who had died in 1948. But John Altoon relied principally on his own inventive intuition, deriving from childlike fantasy, to produce visual mutations done with faultless draftsmanship. The improvisational *Ocean Park* paintings often combine this playful flippancy with sensual humor, delighting the viewer with the imagination of the totally improbable.

In 1964 the artist, knowledgeable about commercial art, acquired an airbrush, and, with the aid of this new gadget, was able to produce a soft mist of color, especially in his works on paper. His oils around this time began to assume a more sonorous aspect. *Untitled #26*, 1964-65 (p. 37), epitomizes the work of this period. The undefined organic shapes are now modeled more illusionistically, so that they appear almost like three-dimensional forms. They are connected by convoluted red ribbons – all set on a dark, mordant rust-colored ground in a painting of high drama. Then, in 1964, he painted a haunting picture (*Untitled [Hyperion Series]*) (p. 36), which, like most of his pieces, is available to multiple individual associations. This painting could be interpreted as the head of Saturn devouring his young – a visualization of the archaic myth of violence and infanticide. But then, perhaps to relieve the sense of tragedy, Altoon, always the satirist, added a pink goblin that seems to have climbed on Saturn's skull.

A work such as this, like most of Altoon's paintings after 1960, is related to the Surrealist tradition. Like Gorky or Miró and Masson before him, Altoon delved into subconscious sources to transcribe dream images. Like the Surrealists, he searched for free associations and strange encounters, pursuing the irrational and the transgressive. Whereas the Abstract Expressionists were greatly concerned with matters of gesture and form, Altoon, like the Surrealists, was more engaged in transcribing and dislocating personal fantasies into visual appearance.

During the time that he was occupied with surreal abstractions, he also made a splendid spoof of an iconic painting by the master of action painting. In *Tattooed Lady*, circa 1964 (p. 31), Altoon placed his rendition of de Kooning's *Woman I* right above the crotch of a naked lady with outstretched arms. He also painted a baseball player above her breast and an American farm couple on her right thigh. To round things out, General Douglas MacArthur, set in front of the Stars and Stripes, is placed on the lady's left thigh. The background of this all-American girl is painted in Baskin-Robbins pink.

Based on his experience as an illustrator, Altoon made a large number of bawdy, satirical drawings that are visual commentaries on sex, lust, and all kinds of perverse erotic fantasies. In *Advertising Series (Bell Telephone)*, circa 1962-63 (p. 30), he depicts a girl who poses for the viewer with her crotch exposed, while the Bell Telephone man busies himself, examining the telephone receiver. Completing the satire, Altoon has placed an abstract painting of stripes on the wall; indeed, Kenneth Noland was exhibiting in Los Angeles at the time. In a highly sardonic model, he spoofs the advertisements of Metropolitan Life by picturing the British Royal Family as they pose for a photo opportunity. The viewer examining this portrait drawing will notice with astonishment that the two male members of the group are exposing their genitals. In the unabashed sexual drawings of 1967 and 1968, the artist enjoyed using his darting and twisting exuberant line for the depiction of erotic play. In *Untitled (ANI #114 Monday)* (p. 47), a naked girl is looking at her monkeylike face in a hand mirror, while a real little monkey is goosing her behind. Or we see a sexy girl looking enticingly at a frog, while another frog slithers from her friend's vagina. There are also drawings of priapic fantasies like *The Dinner Party*, which shows a girl relaxing at a table across from a huge penis that is wiping his glasses to better see the attractive lady. We even see drawings of vulvae smoking cigars and cigarettes. These drawings are far too bizarre to be considered pornographic.

This essay was written at a time when America once more revived its Puritan tradition by resorting to the Judeo-Christian injunction against adultery to investigate and punish innocuous acts of human behavior. What a pleasure to look at these licentious drawings by a painter who, like artists ever since the dawn of prehistory, created art of magic erotic content. Like the work of his Surrealist precursors, the paintings of John Altoon testify to the dynamic power of the erotic to break the bourgeois web of taboos and restore the authentic human being to sensual desire.

Berkeley, June 1997

For Notes, see page 55.

When John Altoon died in the early spring of 1969, it was brutally sudden. Kitaj called from Los Angeles to give me the news, and spoke of having been at a party the night previous at which he'd met John finally, and then shortly after saw him leaving in a rush with Billy Al Bengston, apparently in some difficulty. As it happened, they were on their way to see Dr. Asher, John's friend and collector, to whom he'd previously complained of heartburn, showing up occasionally in the evening with the hope the doctor could fix him up. Suggestions that he come around to the office for a complete checkup never got him there. The "massive coronary" described as cause of death before he had been got to the hospital was the last thing he'd have thought of— still in his early forties, with a life at last solid and productive, and a great deal of the past's psychosis now mitigated, thanks to the help of another friend, Dr. Wexler.

He was so particularly L.A. American, so much the determination of this country's conflicting 'images' of itself, that one is forced willynilly to think of art and artist as one. It was a decisive way of life as well as all else. More, he was a classic storyteller with a humor and a wit that kept working in all manner of demands. So I tell you in large part what he told me without the least interest in whether or not it is precisely true or accurate, as they say, to the facts. We don't live facts, we live our imagination of them.

Long before I ever met John he was already instance of that so-called power of the imagination, and when we did meet, I confess imagination, and his also, was that he would become a successful commercial artist, which is my recollection of what he does in fact get trained to be. Art, in its reflective and aesthetic presence as value, had little to do with either their understanding or needs. You are what you can do.

One of John's stories was how he used to sell newspapers in L.A. and the guy across the street from him, also selling newspapers, was the subsequently terrific science fiction writer Ray Bradbury. He told of the gang he hung out with at the beach, of great destructive challenges like riding motorcycles no hands at speeds exceeding 100 m.p.h., or driving souped-up cars at like speeds, blindfolded. I was dazzled and a very attentive listener. And I believed him and still do, incidentally. For example, my own favorite was the account of the stunted tree, growing in a more or less vacant lot adjacent to Wilshire Boulevard, some well traffic'd section thereof, which John and his cronies managed to turn into a giant slingshot by hacking off its two spare branches to make a crotch, getting a length of inner tube for the sling itself, putting a substantial boulder therein, and laboriously hauling it back as far as they could, then letting go to have the boulder go sailing up over the battered board fence into the traffic (jesus!), hitting thankfully the hood of a car only, and stopping it dead. The kids are long gone before the dazed onlookers can figure out what's happened. Hardly a nice story—but it satisfied some lurking

anger with the part of life that feels like trying to cross an endless street against hordes of indifferent drivers. Or—more honestly— I just like that it worked.

I met John quite unintentionally in 1954, having come back to this country from Mallorca in order to teach at Black Mountain. I'd get to New York as often as I could, crashing variously with friends. One, from college days, a pianist, Race Newton, was living on Spring Street and across the inner court lived an extraordinary lady, Julie Eastman. The novelist Fielding Dawson has given her a distinct immortality in *An Emotional Memoir of Franz Kline* (1967): "Creeley had kept me spellbound about her—the witch from El Paso. Creeley had written a beautiful story about her and the jazz pianist who lived across the courtyard from her, and the jazz trumpeter who lived on the floor below her..." So that was Race, and the other man, also from Boston days, was Ty Frolund. My story was called "The Musicians" and it was by fact of these various associations that I came to know John.

Like Fee, I no sooner met Julie than I was remarkably interested, not in her body, as they say or so I told myself, but in the weirdly pervasive authority she seemed to gather out of the air. Literally I followed her around and so it was she took me along on some of her errands, as she said. One was involved with going up to see Peter Stander, Lionel's bright nephew, then both painter and actor, and also intrigued by Julie—and very jealous on the instant that I was the new attraction although, dumbly, I never figured out his instant hostility until later. And then, that same afternoon, on a corner round about 27th and 4th, we ran into John, who looked me over quickly after Julie's introduction, then asked her about getting his portfolio back. It seems she'd been taking it around for him—he was getting what straight commercial work he could then—and had also been living with him it turned out, but that was now over, but the portfolio hadn't been returned. Dear Julie!

I think I saw John very briefly after that, possibly once or twice. I know I must have given him my address in Mallorca, to where it proved I returned very shortly, to try another year with my wife then (patient woman, but so was I). Anyhow, back in Mallorca, we one day got a letter that John was coming and would have with him two other couples, also painters and their wives, Arthur Okamura (from Los Angeles as was John) and Leon Berkowitz and poet-wife Ida. Terrific! I loved Americans at that point—I'd had the colonial battle all by myself far too long, and no matter Robert Graves and family were most decent to us, and friend then Martin and Jan Seymour-Smith had both got us out of France and kept us company thereafter, it was just a persistently different world, and I was sick unto death of trying to make actual my own. In retrospect, the closest any friend also a painter from that world ever got for me was René Laubiès, a singular man in all respects whom Pound had directed me to—and he showed me Fautrier, Hartung, took me to meet Julien Alvard, etc., but again I

was far more interested by a small show that Pollock had at his gallery, Paul Fachetti's, at that same time—a veritable letter from home.

We were living in Bonanova, up from El Terreno, the suburb of Palma where the heavy money tended to settle. There was a trolley line out from the city and it continued up to the edge of the hills, where John, Arthur and Liz, and Leon and Ida, all managed to find houses. I was very homesick for simple conversation, so almost immediately I began to spend as much time as possible with all the new arrivals, but particularly, as I recall, with John, just that he was by himself and was usually free. He'd set himself up in the garage attached to the house he'd rented, itself packed in against the steep slope of the hill. It was windy up there, and I remember that John's easel, which he'd often put outside, would now and then crash with a sudden gust of wind, dumping the painting on the gravel. I make it sound almost intentionally awkward, on his part, but now recalling, I wonder if he wasn't, in fact, making it as hard on himself as he could. He was working with oils, for example—never a happy means or medium for him, just that the paint physically slowed him in a way ink or airbrush didn't—and to further complicate the process, he'd begun to use raw pigments, mixing them on the spot. It was an incredible sight, these piles of dry pigment, then the sizable can of linseed oil, then John, his eyes on the canvas, reaching out with his free hand to get hold of the oil which he'd pour, still without really looking, on one or more of the piles. Then, with his brush he'd sop some of it up, and off he'd go—remarkably, altogether articulate.

His friends back in New York had been people like Gandy Brodie, mavericks, or certainly inconvenient. John spent time at the Arts Club but never felt easy about it. There was an edge of masters and disciples he didn't easily accept, or not in that manner. He felt it no respect of those one did thus revere, to lean on their agency and provision. He'd told me he'd come to New York specifically as a commercial artist, an up and coming one, in the proverbial lightweight suit, straight from L.A., only to find the weather harshly cold and beyond all expectation. He'd been invited to an annual dinner of successful elders, people like Gilbert Bundy (whom it was felt he might one day take the place of). He was shocked by their cynicism, particularly by Alfred Dorn's taking him over to a window of his penthouse, where the celebration was being held, and pointing out an old tenement where he said he'd grown up and his mother still lived. He could spit on it from that very window, and did. John got drunker and more angry, and after being asked to say something, as the newly arrived youngster, gave them veritable hell, or what he hoped was that. They applauded, and said it was just what they needed, someone to keep them awake. I don't finally know how crucial to him, or successful otherwise, John's commercial work was finally. He drew extraordinarily, always, no matter the occasion—I felt him an absolute genius in this respect—and that gift was equal across the board. For one thing, he never used the usual device that projects an image for tracing, but worked always "free hand"—and did endless studies, in this way, for very mundane drug ads indeed. I don't think it was any question of his perfectionism, call it. He simply felt most active and comfortable working that way.

JOHN ALTOON AT HIS STUDIO IN VENICE, CALIFORNIA, 1968. PHOTOGRAPH BY MALCOLM LUBLINER.

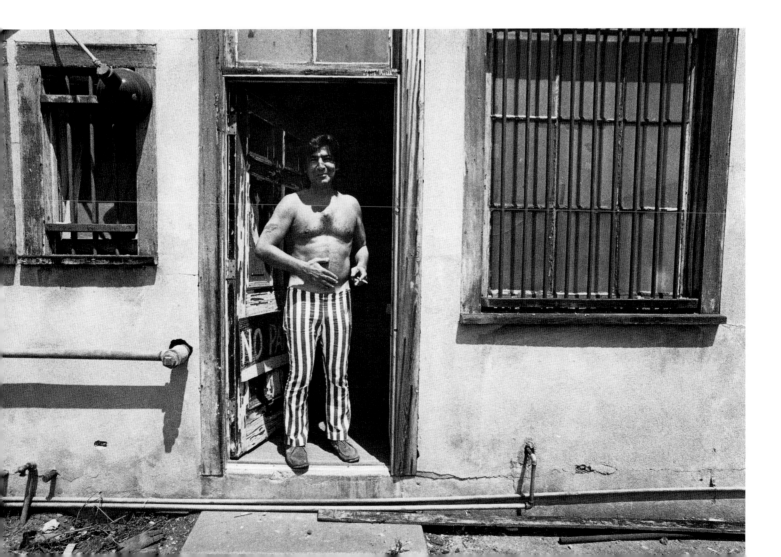

But because of this training, and the facility he brought to it, he was wary of the pretty, or call it the literally beautiful, in common sense. I remember one time he did a hauntingly lovely sketch of my son, David, looked at it, said, *too pretty*, and tore it up. Often he'd smudge, blur, distort, work over, do anything he could to break up the simple, direct containment of his line. He'd watch our kids draw, and delight in how they could know, intuitively, where the action was, where the line could find it.

He was a very warm, intensely reassuring man during this time. I knew nothing of his periodic depressions, actually the paranoid seizures, that so battered him during those years. My own life was falling apart and it seemed to me as if John had some psychically determined intuition of it all. Then, as my wife drew farther away from me, it happened she was drawn to him, and that could have no simple resolution. I left to come back to the States, and for some years only heard occasionally of how he was.

So some time after, I was living in New Mexico, I must have got word of him through some mutual friend like Tony Landreau, or possibly Stu Perkoff, whom I'd just met at his reading in San Francisco, etc., etc. Those particulars are always hard to get exactly. In any case, we were back in touch by the late fifties and my wife, Bobbie, and I would stay with him now and then when we were on the west coast. I recall one place he had then, a sort of bungalow feel to it, somewhat down Wilshire Boulevard, or off in back. There was a younger man living with him, whom he'd befriended—shy, raw in manner, very loyal to John, I remember he gave Bobbie a little leather purse he'd made, as a compliment. John himself gave us *many* drawings; I was embarrassed but deeply pleased and grateful to have them. He was working in ink, drawing with intensely quick resolution, extraordinary haunting suggestions of people, things, very often animals or birds. I have one of a mournful crow-seeming bird, with a little window of sorts in its breast, with a little man's face in that. I could dig it, like they say. He'd give us piles of them to look through, they were on a mat board, often very large—there was just no way to make a simple choice, or probably one wanted them all.

When John talked of women in the abstract, like they say also, he gave a sense of this utterly blonde, clean, white person, impeccably erotic often, but with no pubic hair, for example, and really no odor nor tone of any specifying kind. She was the American dream, in short, and she was far more a defense, I thought, as an image, than any active desire. I know that John had girl friends who were the classic dumb blondes—but I don't know that, I'm only saying they *looked* great, and were always nice to me. I never had a chance to know his first wife, Fay Spain—we talked once on the telephone after they'd separated and her intelligence and care of him was very moving. He had said it was the money that had made it hard, the fact she could go out and buy a Mercedes the way he might a pair of pants. When he went on location with her, he was the awkward, in the way husband. That could never sit well with him, despite how much they shared as people who had made it the hard way.

Then, more years later, after a time out in Santa Monica—I recall a great time on the carousel with John's terrific dog running round and round after us—he was back in a place on Harper. (He did a great series of that name, sadly slashed during a time of breakdown.) But writing, I can't trust my memory of the time

pattern. But this I do remember very vividly. I was in L.A. again, another old friend, Neil Williams, was there also, and he knew John well. Neil was telling me about John's *great* new wife, Babs—which proved utterly true. He said she really ate and I should watch her in action. So not long after, as it happens, we all four went out for dinner and I think we had the proverbial steaks, which tend to get filling, after ample drink, so it seems we variously left this and that, the salad, the bread, the steak, etc. All of which Babs politely, quietly, and completely ate up. God knows where it went, she never showed it. I think the fact was she had a factually healthy person, as my mother would say, and the system was working perfectly.

At this point I feel empty that so much hasn't got said here, even arguments I'd like to continue on John's behalf as to why hasn't there been more use of him. Not much is so good or so humanly relieving. Talking to Tibor de Nagy one time at his gallery, being there to see what he had of John's, in fact, he said that possibly people were intimidated, even spooked, by the humor. They didn't know what to do with a picture that was so inescapably funny, and if it was in part laughing at them, it surely could be with them also. John invited me generously into a portfolio once, the first Gemini ever did and the first ever of his lithographs—and we cast about for a title, and ended up with a pretty crunky one, *Of Women*. Not even Picasso ran so many particularizing numbers on that possibility as did John—cowboys and Indians, the works. My own favorite is one of the usual dowdily buxom lady leaning over the fence to attend a gesticulating, squatty, and naked man, who is pontificating in an amiable way whilst his erect and knobby malehood stands forth from him in a charmingly emphasized way, i.e., the head is a singularly yellow rose. Well, one picture is worth a thousand words—but don't tell me art doesn't *mean* something. John Altoon always did and so do I. If you don't mean it, why bother.

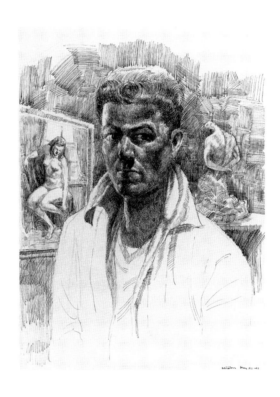

SELF PORTRAIT (RECTO); STUDY AFTER THE ANTIQUE (VERSO), 5/23/1947, PEN AND BLACK INK ON OFF-WHITE WOVE PAPER, COLORED CHALKS, 24 13/16 × 18 1/8 INCHES (61.5 × 46 CM)
COLLECTION FINE ARTS MUSEUMS OF SAN FRANCISCO, ACHENBACH FOUNDATION FOR GRAPHIC ARTS, ANONYMOUS GIFT

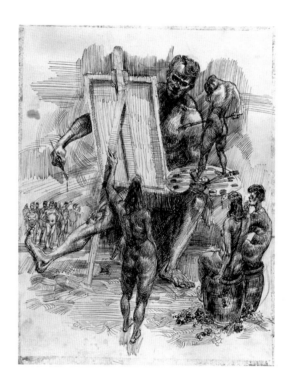

THE ARTIST AND MODELS (SELF PORTRAIT), CIRCA 1949, BLACK INK OVER GRAPHITE ON PAPER, 24 7/8 × 19 15/16 INCHES (63.2 × 50.6 CM)
COLLECTION FINE ARTS MUSEUMS OF SAN FRANCISCO, ACHENBACH FOUNDATION FOR GRAPHIC ARTS, GIFT OF ANITA NAZ MARDIKIAN

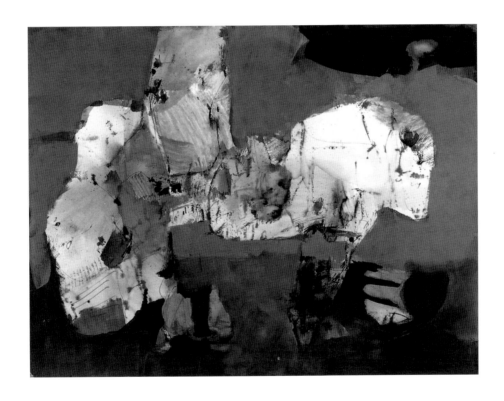

A, 1956, WATERCOLOR, PEN AND OIL ON ILLUSTRATION BOARD, 30 1/8 × 40 1/8 INCHES (76.5 × 101.9 CM)
COLLECTION NORTON SIMON MUSEUM, PASADENA, CALIFORNIA WATERCOLOR SOCIETY PURCHASE AWARD

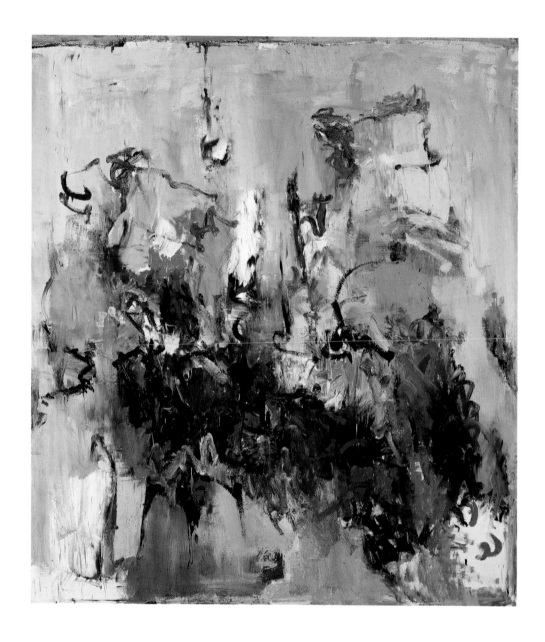

Fay's Christmas Painting, 1958, oil on canvas, 72 x 64-5/8 inches (182.9 x 164.1 cm)
Collection Norton Simon Museum, Pasadena, Gift of Mr. William B. Janss

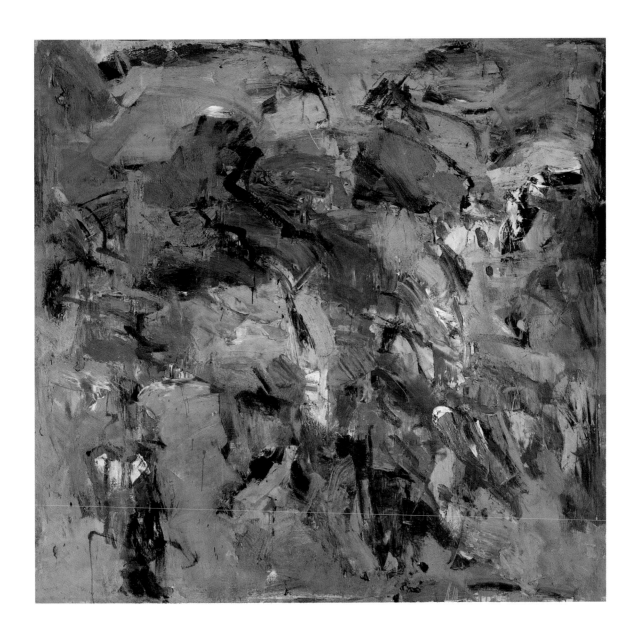

Untitled, 1959, oil on canvas, 70 x 74 inches (177.8 x 188 cm)
Collection Elizabeth and L.J. Cella

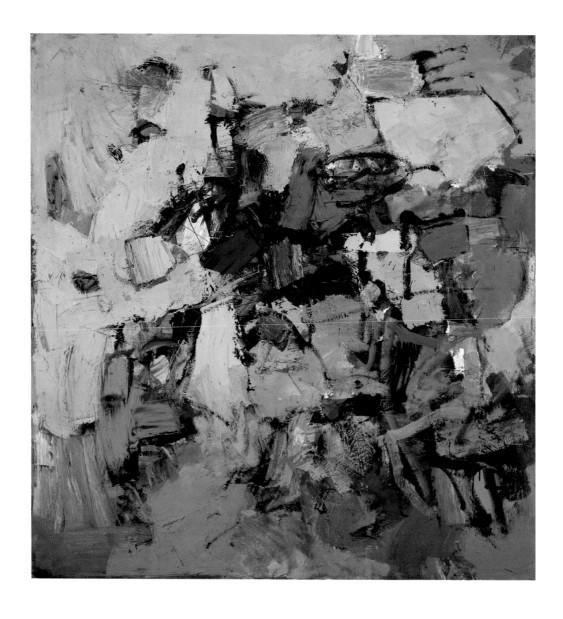

UNTITLED, 1959, OIL ON CANVAS, 69 × 65-1/2 INCHES (175.3 × 166.4 CM)
COLLECTION MUSEUM OF CONTEMPORARY ART, SAN DIEGO, PURCHASE

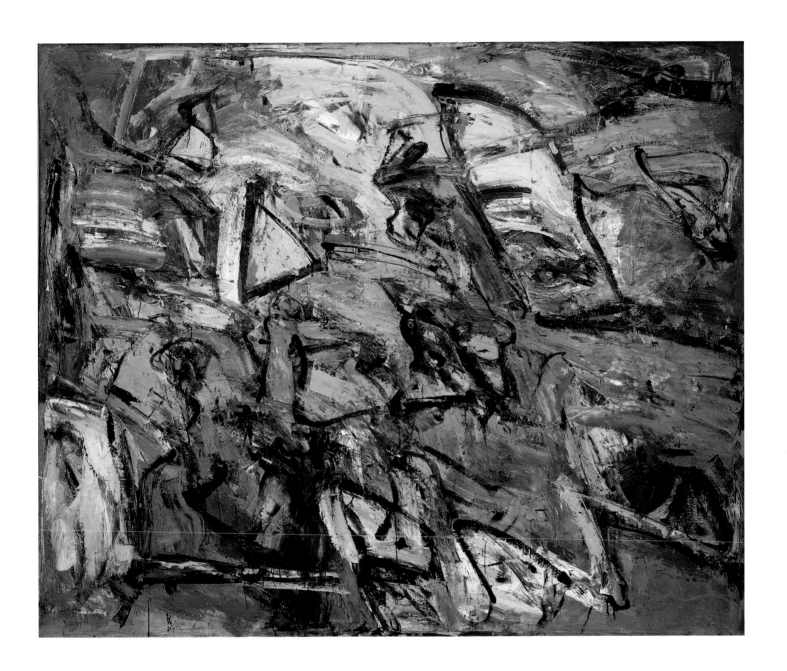

Untitled (Trip #2), 1959, oil on canvas, 80 × 96 inches (203.2 × 243.8 cm)
Collection Dennis Hopper

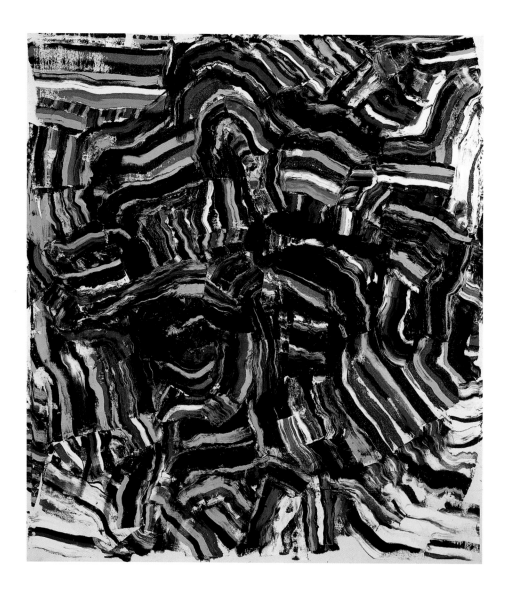

Untitled (Trip Series), 1959, oil on canvas, 53 5/8 × 48 inches (136.2 × 121.9 cm)
Collection Norton Simon Museum, Pasadena, Gift of Robert A. Rowan

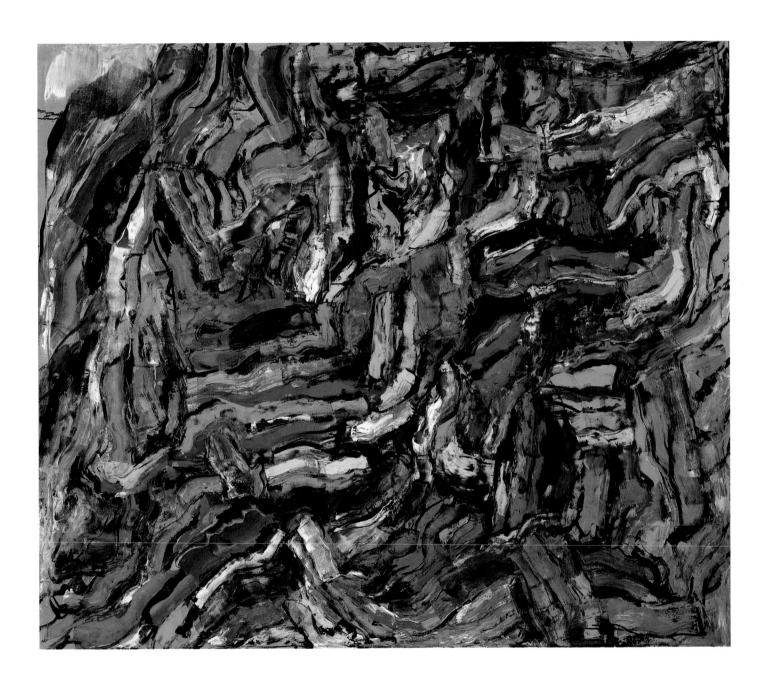

UNTITLED (TRIP SERIES), 1959, OIL ON CANVAS, 69-3/4 × 82 INCHES (177.2 × 280.3 CM)
COLLECTION MUSEUM OF CONTEMPORARY ART, SAN DIEGO, GIFT OF RUTH AND MURRAY GRIBIN

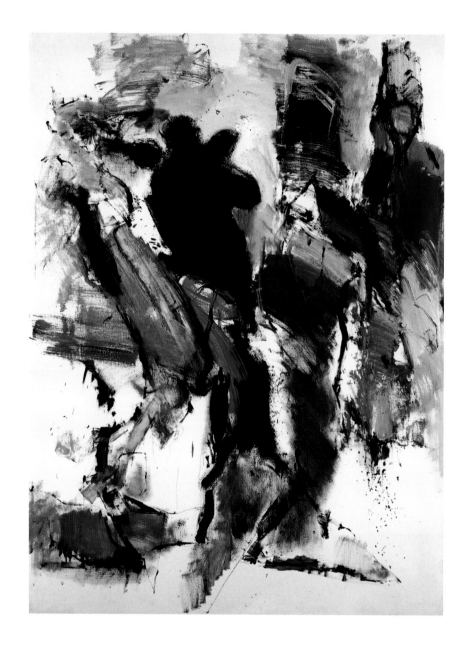

Untitled, 1960, oil on canvas, 58 1/2 x 43 inches (148.6 x 109.2 cm)
Collection Louis F. D'Elia

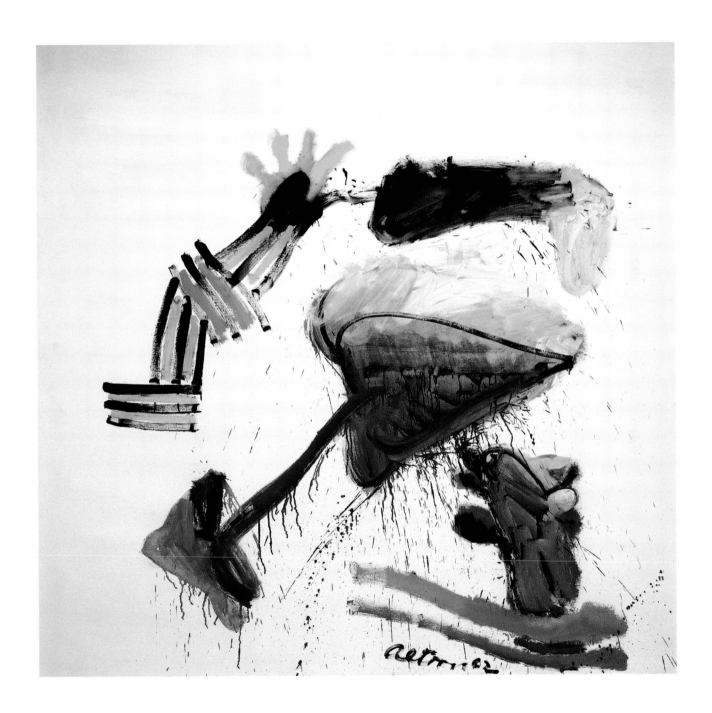

Ocean Park Series #8, 1962, oil on canvas, 81 1/2 × 84 inches (206.5 × 213.4 cm)
Collection Norton Simon Museum, Pasadena, Anonymous Gift

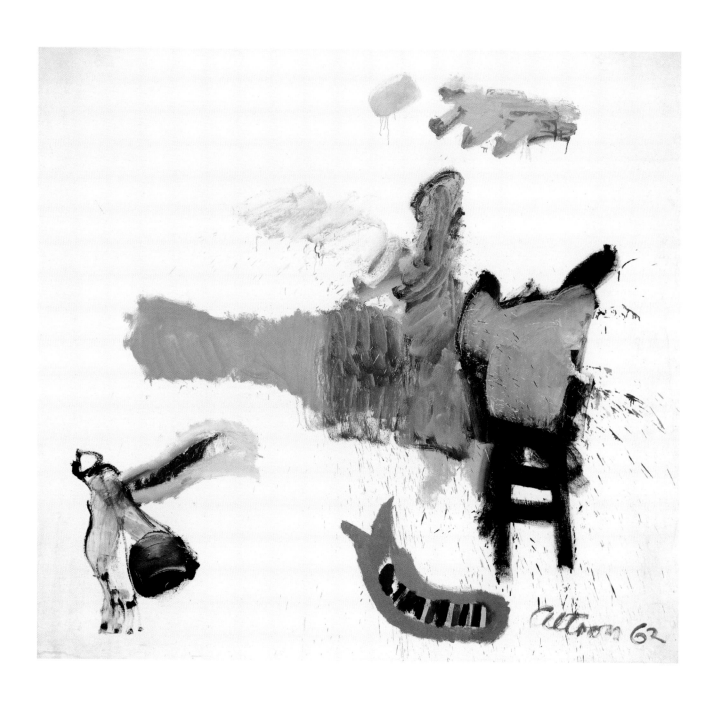

Ocean Park Series, 1962, oil on canvas, 72 x 84 inches (182.9 x 213.4 cm)
Collection Orange County Museum of Art, Newport Beach

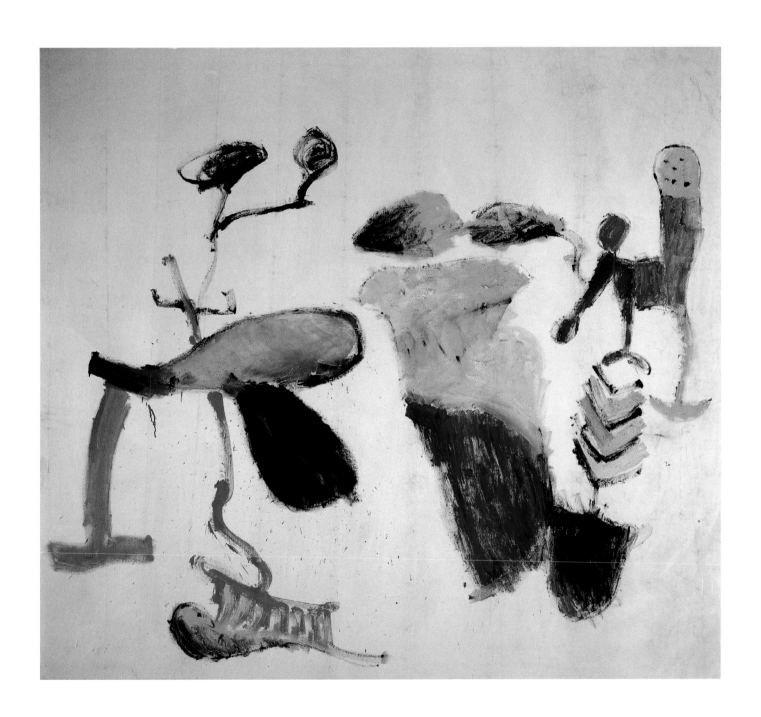

OCEAN PARK SERIES, 1962, OIL ON CANVAS, 79 × 88 1/2 INCHES (200.7 × 224.8 CM)
COLLECTION RUTH AND MURRAY GRIBIN

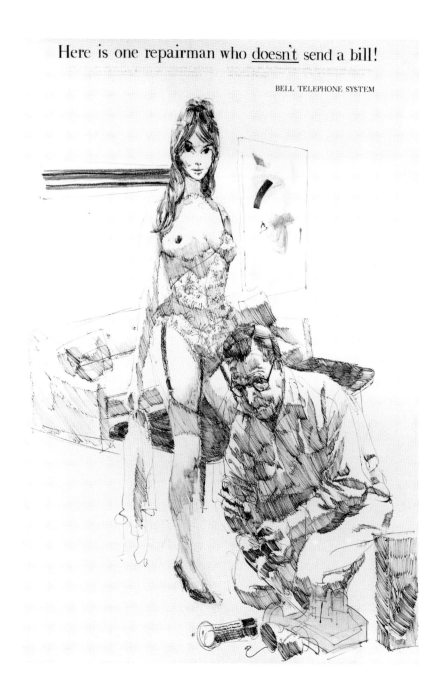

ADVERTISING SERIES (BELL TELEPHONE), CIRCA 1962-63, PEN, INK AND PASTEL ON ILLUSTRATION BOARD, 60 × 40 INCHES (152.4 × 101.6 CM)
ESTATE OF JOHN ALTOON, COURTESY BRAUNSTEIN/QUAY GALLERY, SAN FRANCISCO

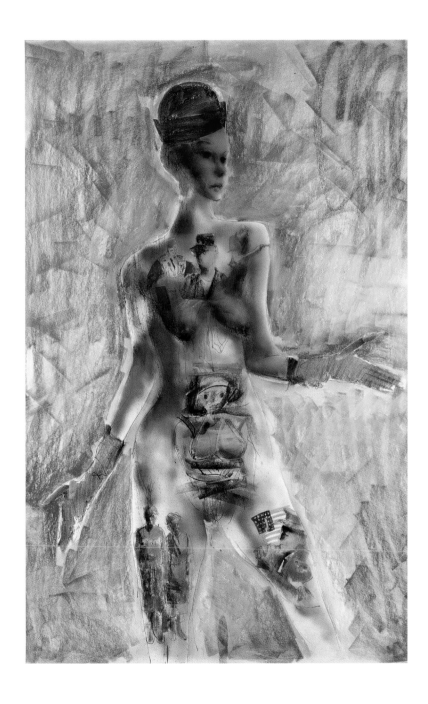

Tattooed Lady, circa 1964, pastel on paper, 60 x 40 inches (152.4 x 101.6 cm)
Collection Dr. Milton Wexler

HYPERION SERIES, 1964, OIL, INK, CRAYON, PENCIL AND AIRBRUSH ON CANVAS, 29 11/16 x 39 1/2 INCHES (75.4 x 100.3 CM)
COLLECTION LOS ANGELES COUNTY MUSEUM OF ART, GIFT OF MRS. LITA A. HAZEN

SAWTELLE SERIES, 1964, INK ON ILLUSTRATION BOARD, 30 × 40 INCHES (76.2 × 101.6 CM)
COLLECTION MUSEUM OF CONTEMPORARY ART, SAN DIEGO, PURCHASE

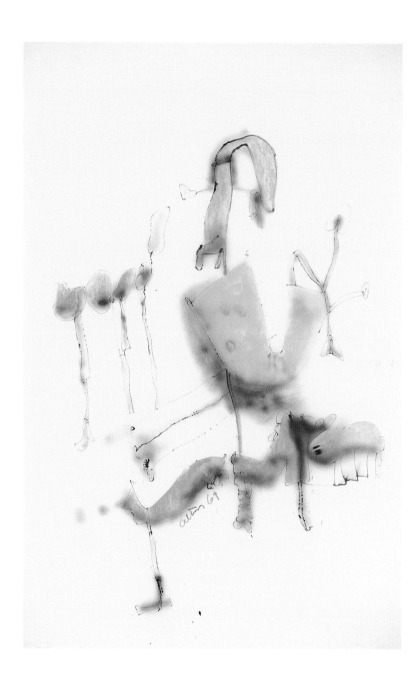

Sunset Series, 1964, black ink, water based media and pastel on illustration board, 60 × 40 inches (152.4 × 101.6 cm)
Collection San Francisco Museum of Modern Art, Purchase

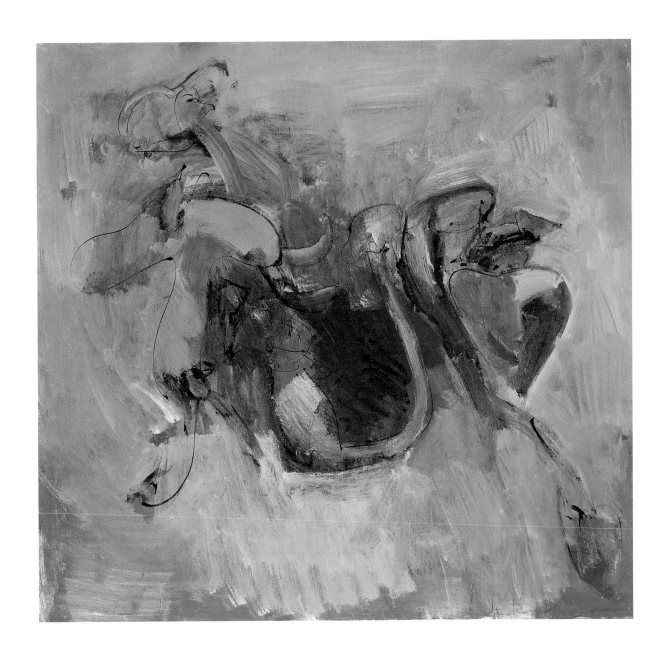

Untitled, 1964, oil on canvas, 56 x 60 inches (142.2 x 152.4 cm)
Collection Mr. and Mrs. Joseph Smith

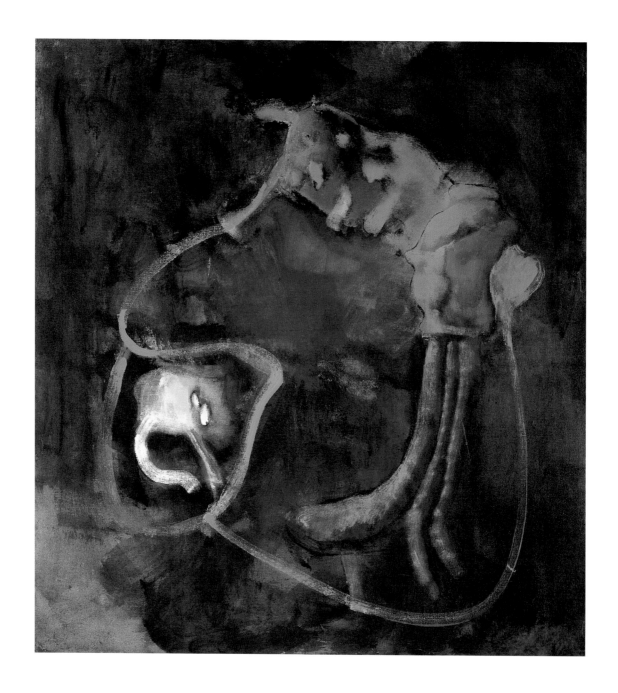

Untitled (Hyperion Series), 1964, oil on canvas, 60 x 56 1/2 inches (152.4 x 143.5 cm)
Collection Ruth and Murray Gribin

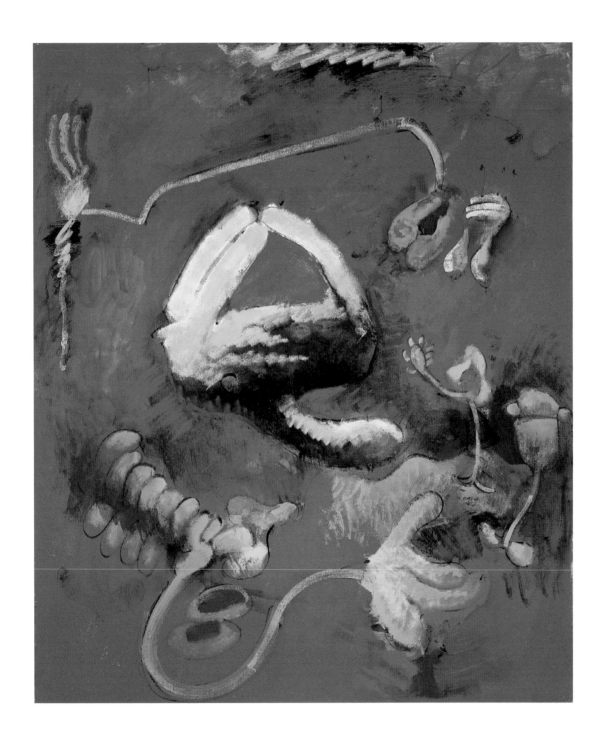

Untitled #26, 1964-65, oil on canvas, 66 x 56 inches (167.6 x 142.2 cm)
Collection SunAmerica Collection, Los Angeles

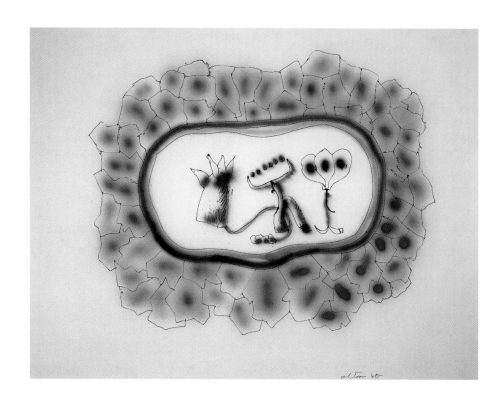

Untitled, 1965, ink and pencil on paper, 30 1/6 x 40 1/8 inches (76.2 x 102 cm)
Collection Museum of Contemporary Art, San Diego, Gift of Daniel Weinberg

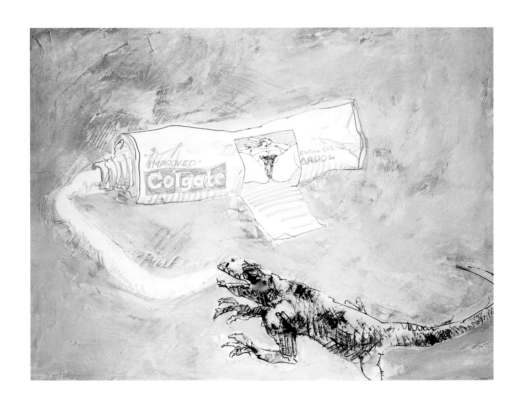

Untitled (Colgate), circa 1964-66, (with Edward Ruscha, b. 1937), ink, watercolor and pastel on paper, 29 x 39 inches (73.7 x 99.1 cm)
Collection Dennis Hopper

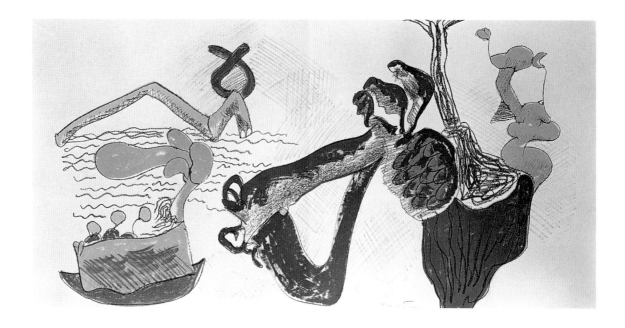

ABOUT WOMEN, 1965-66, LITHOGRAPH, EDITION 6 OF 100, 19 × 38 INCHES (48.3 × 96.5 CM)
COLLECTION MUSEUM OF CONTEMPORARY ART, SAN DIEGO, PURCHASE

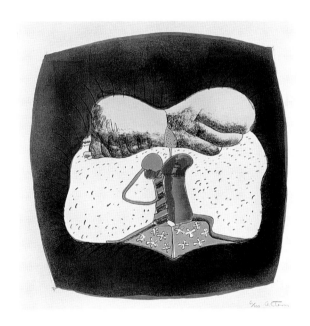

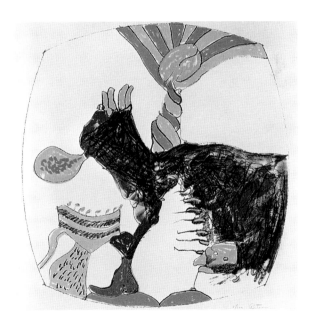

ABOUT WOMEN, 1965-66, LITHOGRAPH, EDITION 6 OF 100, 19 × 19 INCHES EACH (48.3 × 48.3 CM)
COLLECTION MUSEUM OF CONTEMPORARY ART, SAN DIEGO, PURCHASE

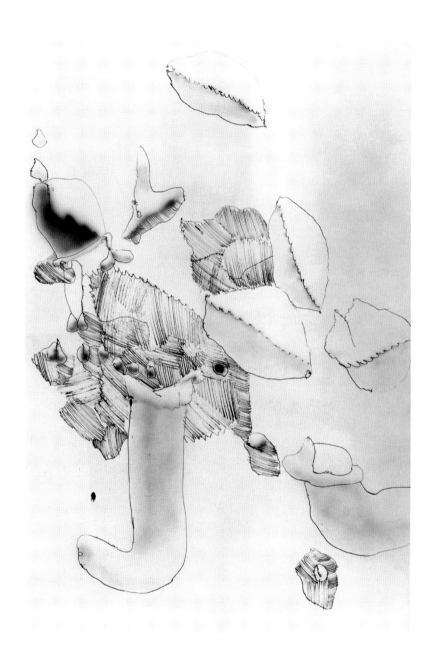

EARLY '66, 1966, INK, WATERCOLOR AND AIRBRUSH ON PAPER, 60 x 40 INCHES (152.4 x 101.6 CM)
COLLECTION LOS ANGELES COUNTY MUSEUM OF ART, GIFT OF BARRY LOWEN

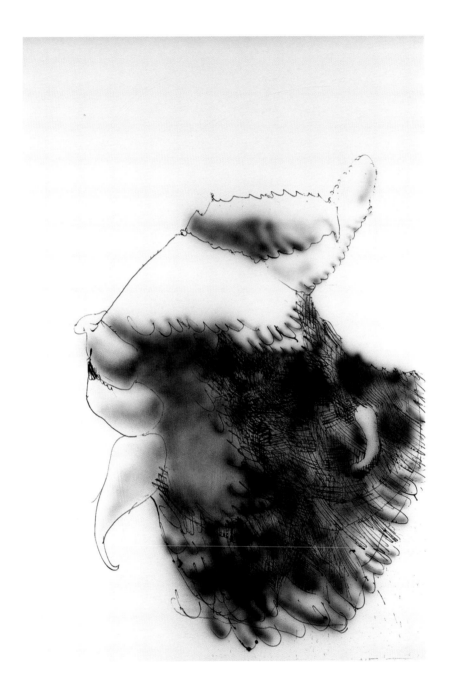

Harper Series #10, 1966, ink and acrylic on illustration board, 60 x 40 1/2 inches (152.4 x 103 cm)
Collection Dr. Milton Wexler

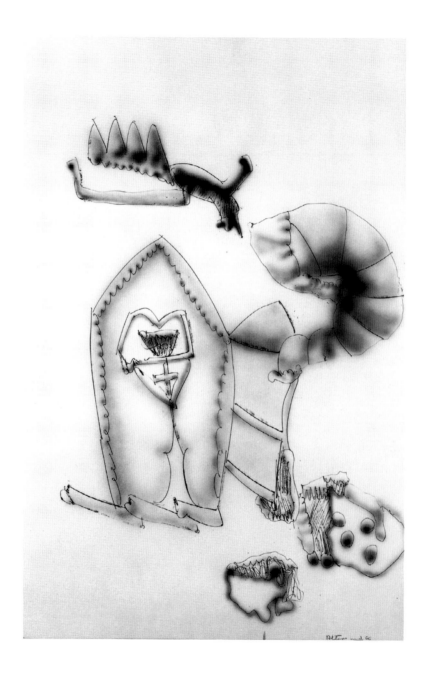

Jim's Fancy (From the Harper Series), 1966, pen, ink and watercolor on illustration board, 60 1/8 × 40 1/8 inches (152.7 × 101.9 cm)
Collection Norton Simon Museum of Art, Pasadena, Gift of the Artist

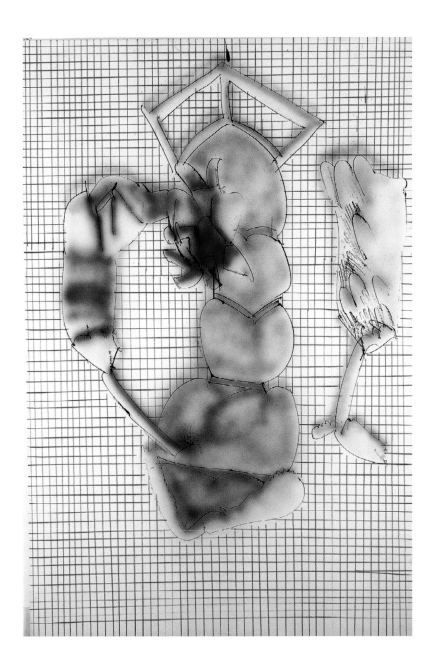

Untitled (ABS-72A), 1966, pen, ink and colored pencil on illustration board, 60 × 40 inches (152.4 × 101.6 cm)
Estate of John Altoon, Courtesy Braunstein/Quay Gallery, San Francisco

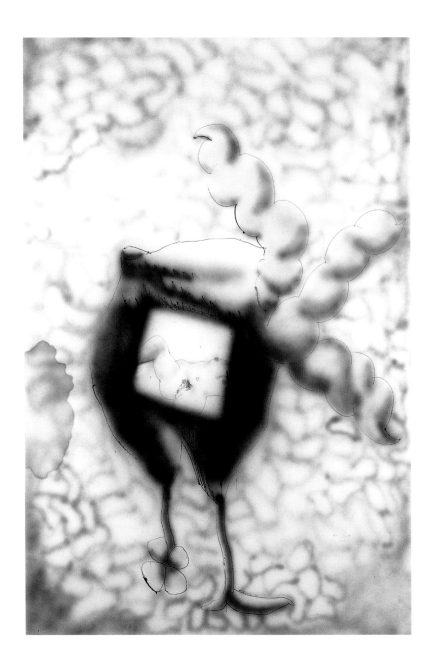

UNTITLED (ABS-81A), 1966, PEN, INK AND WATERCOLOR ON ILLUSTRATION BOARD, 60 × 40 INCHES (152.4 × 101.6 CM)
ESTATE OF JOHN ALTOON, COURTESY BRAUNSTEIN/QUAY GALLERY, SAN FRANCISCO

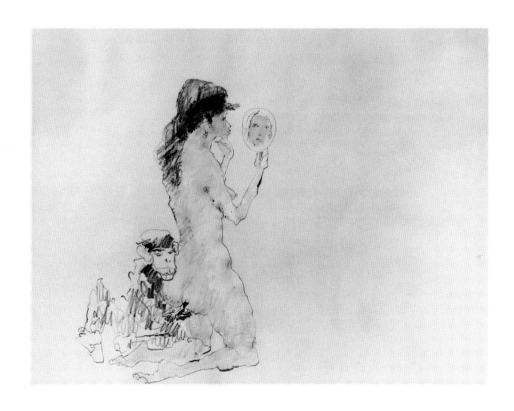

Untitled (ANI #114 monday), 1967, gouache and crayon on paper, 30 1/2 x 40 inches (77.5 x 101.6 cm)
Collection San Francisco Museum of Modern Art, Bequest of Alfred M. Esberg

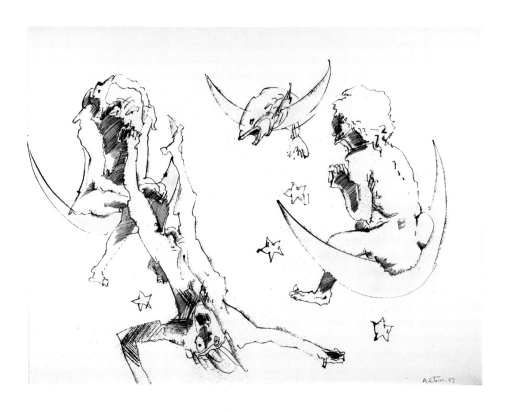

Untitled (F-105), 1967, pen, ink and watercolor on illustration board, 30 × 40 inches (76.2 × 101.6 cm)
Anonymous Loan

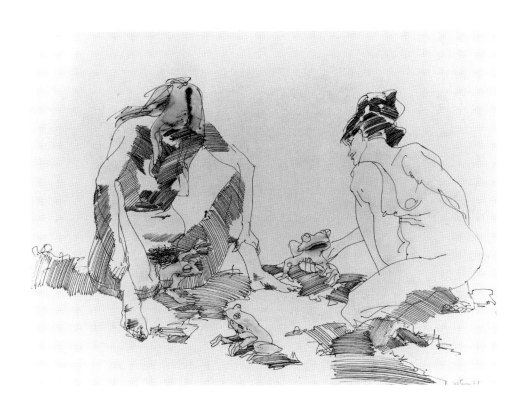

Princess and the Frog #12, 1968, ink, watercolor and airbrush on illustration board, 30 × 40 1/4 inches (76.2 × 101.6 cm)
Collection University of California, Berkeley Art Museum, Museum Purchase

Untitled (OBJ-4), 1968, colored pencils and watercolor on illustration board, 29 15/16 × 39 13/16 inches (76 × 101.2 cm)
Collection Fine Arts Museums of San Francisco, Achenbach Foundation for Graphic Arts, Gift of Roselyne and Richard Swig

EXHIBITION CHECKLIST

Self Portrait (recto); Study After the Antique (verso),
5/23/1947
pen and black ink on off-white wove paper,
colored chalks
24 13/16 x 18 1/8 inches (61.5 x 46 cm)
Collection Fine Arts Museums of San Francisco,
Achenbach Foundation for Graphic Arts, Anonymous Gift

The Artist and Models (Self Portrait), circa 1949
black ink over graphite on paper
24 7/8 x 19 15/16 inches (63.2 x 50.6 cm)
Collection Fine Arts Museums of San Francisco,
Achenbach Foundation for Graphic Arts,
Gift of Anita Naz Mardikian

Untitled, circa 1951
ink on paper
18 x 15 inches (45.7 x 38.1 cm)
Collection Museum of Contemporary Art, San Diego,
Gift of Mr. and Mrs. Donald Brewer, 1965.209

Blind Accordion Player, 1951
ink on paper
18 1/2 x 15 1/2 inches (45 x 39.4)
Collection Museum of Contemporary Art, San Diego,
Gift of Mr. and Mrs. Donald Brewer, 1961.89

A, 1956
watercolor, pen and oil on illustration board
30 1/8 x 40 1/8 inches (76.5 x 101.9 cm)
Collection Norton Simon Museum, Pasadena,
California Watercolor Society, Purchase Award, 1957

Fay's Christmas Painting, 1958
oil on canvas
72 x 64 5/8 inches (182.9 x 164.1 cm)
Collection Norton Simon Museum, Pasadena,
Gift of Mr. William B. Janss, 1964

Untitled, 1959
oil on canvas
70 x 74 inches (177.8 x 188 cm)
Collection Elizabeth and L.J. Cella

Untitled, 1959
oil on canvas
69 x 65 1/2 inches (175.3 x 166.4 cm)
Collection Museum of Contemporary Art, San Diego,
Purchase, 1961.3

Untitled (Trip # 2), 1959
oil on canvas
80 x 96 inches (203.2 x 243.8 cm)
Collection Dennis Hopper

Untitled (Trip Series), 1959
oil on canvas
53 5/8 x 48 inches (136.2 x 121.9 cm)
Collection Norton Simon Museum, Pasadena,
Gift of Robert A. Rowan, 1964

Untitled (Trip Series), 1959
oil on canvas
69 3/4 x 82 inches (177.2 x 208.3 cm)
Collection Museum of Contemporary Art, San Diego,
Gift of Ruth and Murray Gribin, 1985.20

Untitled, circa 1960
oil on canvas
91 x 70 1/2 inches (231.1 x 179.1 cm)
Collection Roberta L. Thomson

Untitled, circa 1960
oil on canvas
72 x 55 1/2 inches (182.9 x 141 cm)
Collection Roberta L. Thomson

Untitled, 1960
ink on illustration board
30 x 40 inches (76.2 x 101.6 cm)
Collection Museum of Contemporary Art, San Diego,
Gift of the Artist, 1961.1

Untitled, 1960
oil on canvas
58 1/2 x 43 inches (148.6 x 109.2 cm)
Collection Louis F. D'Elia

Untitled, 1961
gouache and colored crayons on illustration board
29 3/4 x 40 inches (75.9 x 101.6 cm)
Collection The Museum of Contemporary Art,
Los Angeles, Gift of Lannan Foundation

Ocean Park Series #8, 1962
oil on canvas
81 1/2 x 84 inches (206.5 x 213.4 cm)
Collection Norton Simon Museum, Pasadena,
Anonymous Gift, 1964

Ocean Park Series #12, 1962
oil on canvas
81 1/2 x 84 inches (207 x 213.4 cm)
Collection Los Angeles County Museum of Art,
Gift of Dr. and Mrs. Eugene Ziskind

Ocean Park Series, 1962
oil on canvas
72 x 84 inches (182.9 x 213.4 cm)
Collection Orange County Museum of Art,
Newport Beach

Ocean Park Series, 1962
oil on canvas
79 x 88 1/2 inches (200.7 x 224.8 cm)
Collection Ruth and Murray Gribin

Advertising Series (Bell Telephone),
circa 1962-63
pen, ink and pastel on illustration board
60 x 40 inches (152.4 x 101.6 cm)
Estate of John Altoon, Courtesy Braunstein/Quay Gallery,
San Francisco

Advertising Series (Metropolitan Life),
circa 1962-63
pen, ink and pastel on illustration board
60 x 40 inches (152.4 x 101.6 cm)
Estate of John Altoon, Courtesy Braunstein/Quay Gallery,
San Francisco

Satire Series: Hunts, 1963
acrylic on illustration board
59 1/2 x 40 inches (151.1 x 101.6 cm)
Collection San Diego Museum of Art,
Gift of the Frederick R. Weisman Art Foundation

Tattooed Lady, circa 1964
pastel on paper
60 x 40 inches (152.4 x 101.6 cm)
Collection Dr. Milton Wexler

Untitled (Woman with Mirror), circa 1964
ink and spray paint on illustration board
30 x 40 inches (76.2 x 101.6 cm)
Collection Dr. Milton Wexler

Hyperion Series, 1964
oil, ink, crayon, pencil and airbrush on canvas
29 11/16 x 39 1/2 inches (75.4 x 100.3 cm)
Collection Los Angeles County Museum of Art,
Gift of Mrs. Lita A. Hazen

Sawtelle Series, 1964
ink on illustration board
30 x 40 inches (76.2 x 101.6 cm)
Collection Museum of Contemporary Art, San Diego,
Purchase, 1966.2

Sunset Series, 1964
black ink, water based media and pastel
on illustration board
60 x 40 inches (152.4 x 101.6 cm)
Collection San Francisco Museum of Modern Art,
Purchase

Untitled, 1964
ink and acrylic on illustration board
60 x 39 3/4 inches (152.4 x 101 cm)
Collection Museum of Contemporary Art, San Diego,
Gift of Ruth and Murray Gribin, 1983.10

Untitled, 1964
oil on canvas
56 x 60 inches (142.2 x 152.4 cm)
Collection Mr. and Mrs. Joseph Smith

Untitled (Hyperion Series), 1964
oil on canvas
60 x 56 1/2 inches (152.4 x 143.5 cm)
Collection Ruth and Murray Gribin

Sunset Series, 1964-65
oil on canvas
60 x 56 inches (152.4 x 142.2 cm)
Collection Roberta L. Thomson

Untitled #26, 1964-65
oil on canvas
66 x 56 inches (167.6 x 142.2 cm)
Collection SunAmerica Collection, Los Angeles

Untitled, 1965
oil on canvas
60 x 56 inches (152.4 x 142.2 cm)
Collection Fine Arts Museums of San Francisco,
Gift of Deborah and Joseph Goldyne

Untitled, 1965
ink and pencil on illustration board
30 x 40 1/8 inches (76.2 x 101.9 cm)
Collection Museum of Contemporary Art, San Diego,
Gift of Daniel Weinberg, 1979.23

Untitled (Tamarind #1328), 1965
lithograph, edition of 9 Tamarind Impressions
22 3/8 x 30 inches (56.8 x 76.2 cm)
Collection Museum of Contemporary Art, San Diego,
Gift of Mr. and Mrs. Martin L Gleich, 1966.30

Untitled (Tamarind #1330), 1965
lithograph, edition of 9 Tamarind Impressions
22 1/4 x 30 inches (56.5 x 76.2 cm)
Collection Museum of Contemporary Art, San Diego,
Gift of Mr. and Mrs. Martin L Gleich, 1966.29

Untitled (Tamarind #1333), 1965
lithograph, edition of 9 Tamarind Impressions
22 3/8 x 30 1/8 inches (56.8 x 76.5 cm)
Collection Museum of Contemporary Art, San Diego,
Gift of Mr. and Mrs. Martin L Gleich, 1966.31

Untitled (Tamarind #1354), 1965
lithograph, edition of 9 Tamarind Impressions
22 1/4 x 30 1/4 inches (56.5 x 76.8 cm)
Collection Museum of Contemporary Art, San Diego,
Gift of Mr. and Mrs. Martin L Gleich, 1966.33

Untitled (Colgate), circa 1964-66
(with Edward Ruscha, b. 1937)
ink, watercolor and pastel on illustration board
29 x 39 inches (73.7 x 99.1 cm)
Collection Dennis Hopper

About Women, 1965-66
(poem by Robert Creeley, b. 1926)
lithograph, edition 6 of 100
19 x 19 inches each (48.3 x 48.3 cm)
Collection Museum of Contemporary Art, San Diego,
Purchase, 1966.8.3-.4

About Women, 1965-66
lithograph, edition 6 of 100
19 x 19 inches (48.3 x 48.3 cm)
Collection Museum of Contemporary Art, San Diego,
Purchase, 1966.8.8

About Women, 1965-66
lithograph, edition 6 of 100
19 x 19 inches (48.3 x 48.3 cm)
Collection Museum of Contemporary Art, San Diego,
Purchase, 1966.8.9

About Women, 1965-66
lithograph, edition 6 of 100
19 x 19 inches (48.3 x 48.3 cm)
Collection Museum of Contemporary Art, San Diego,
Purchase, 1966.8.11

About Women, 1965-66
lithograph, edition 6 of 100
19 x 38 inches (48.3 x 96.5 cm)
Collection Museum of Contemporary Art, San Diego,
Purchase, 1966.8.17

About Women, 1966
pastel on paper
19 x 19 inches (48.3 x 48.3 cm)
Collection Museum of Contemporary Art, San Diego,
Purchase, 1966.8.18

EXHIBITION CHECKLIST CONTINUED

Early '66, 1966
ink, watercolor and airbrush on illustration board
60 x 40 inches (152.4 x 101.6 cm)
Collection Los Angeles County Museum of Art,
Gift of Barry Lowen

Harper Series #10, 1966
ink and acrylic on illustration board
60 x 40 1/2 inches (152.4 x 103 cm)
Collection Dr. Milton Wexler

Jim's Fancy (From the Harper Series), 1966
pen, ink and watercolor on illustration board
60 1/8 x 40 1/8 inches (152.7 x 101.9 cm)
Collection Norton Simon Museum, Pasadena,
Gift of the Artist, 1966

Shoot the Baby, 1966
watercolor and ink on illustration board
30 1/4 x 40 1/4 inches (76.8 x 102.2 cm)
Collection The Museum of Contemporary Art,
Los Angeles, Gift of the Ferrier Family: Anne, John Jr.,
Katie and Stuart

Untitled (ABS-12), 1966
pen, ink and watercolor on illustration board
60 x 40 inches (152.4 x 101.6 cm)
Anonymous Loan

Untitled (ABS-41), 1966
pen, ink and watercolor on illustration board
60 x 40 inches (152.4 x 101.6 cm)
Estate of John Altoon, Courtesy Braunstein/Quay Gallery,
San Francisco

Untitled (ABS-72A), 1966
pen, ink and colored pencil on illustration board
60 x 40 inches (152.4 x 101.6 cm)
Estate of John Altoon, Courtesy Braunstein/Quay Gallery,
San Francisco

Untitled (ABS-81A), 1966
pen, ink and watercolor on illustration board
60 x 40 inches (152.4 x 101.6 cm)
Estate of John Altoon, Courtesy Braunstein/Quay Gallery,
San Francisco

Untitled (J111a), 1966
black ink, water based media and pastel
on illustration board
59 7/8 x 39 7/8 inches (152.1 x 101.3 cm)
Collection San Francisco Museum of Modern Art,
Gift of Mr. and Mrs. William C. Janss

Untitled (ANI #114 Monday), 1967
gouache and crayon on paper
30 1/2 x 40 inches (77.5 x 101.6 cm)
Collection San Francisco Museum of Modern Art,
Bequest of Alfred M. Esberg

Untitled (F-105), 1967
pen, ink and watercolor on illustration board
30 x 40 inches (76.2 x 101.6 cm)
Anonymous Loan

Princess and the Frog #12, 1968
ink, watercolor and airbrush on illustration board
30 x 40 1/4 inches (76.2 x 101.6 cm)
Collection University of California, Berkeley Art Museum,
Museum Purchase

Untitled (ABS-42), 1968
airbrush, ink, watercolor and pastel on illustration
board
30 x 40 inches (76.2 x 101.6 cm)
Collection Roberta L. Thomson

Untitled (ANI-98), 1968
pen, ink, and watercolor on illustration board
30 x 40 inches (76.2 x 101.6 cm)
Collection Roberta L. Thomson

Untitled (The Dinner Party), 1968
pen and ink on illustration board
30 x 40 inches (76.2 x 101.6 cm)
Estate of John Altoon, Courtesy Braunstein/Quay Gallery,
San Francisco

Untitled (F-8), 1968
pen, ink and watercolor on illustration board
30 x 40 inches (76.2 x 101.6 cm)
Anonymous Loan

Untitled (OBJ-4), 1968
colored pencils and watercolor on illustration board
29 15/16 x 39 13/16 inches (76 x 101.2 cm)
Collection Fine Arts Museums of San Francisco,
Achenbach Foundation for Graphic Arts,
Gift of Roselyne and Richard Swig

Untitled (OBJ-42), 1968
pastel and black ink on illustration board
29 15/16 x 40 1/16 inches (76 x 101.8 cm)
Collection Fine Arts Museums of San Francisco,
Achenbach Foundation for Graphic Arts,
Gift of Roselyne and Richard Swig

Untitled (Tamarind #2183), 1968
lithograph, edition of 9 Tamarind Impressions
22 3/4 x 30 inches (57.8 x 76.2 cm)
Collection Museum of Contemporary Art, San Diego,
Gift of Mr. and Mrs. Martin L. Gleich, 1972.283

Untitled (Tamarind #2184), 1968
lithograph, edition of 9 Tamarind Impressions
22 1/2 x 30 inches (57 x 76.2 cm)
Collection Museum of Contemporary Art, San Diego,
Gift of Mr. and Mrs. Martin L. Gleich, 1972.282

Untitled (Tamarind #2188), 1968
lithograph, edition of 9 Tamarind Impressions
22 1/2 x 30 inches (57 x 76.2 cm)
Collection Museum of Contemporary Art, San Diego,
Gift of Mr. and Mrs. Martin L. Gleich, 1972.279

Untitled (Tamarind #2189), 1968
lithograph, edition of 9 Tamarind Impressions
22 1/2 x 30 1/8 inches (57 x 76.4 cm)
Collection Museum of Contemporary Art, San Diego,
Gift of Mr. and Mrs. Martin L. Gleich, 1972.278

Untitled (Tamarind #2191), 1968
lithograph, edition of 9 Tamarind Impressions
22 1/2 x 30 inches (57 x 76.2 cm)
Collection Museum of Contemporary Art, San Diego,
Gift of Mr. and Mrs. Martin L. Gleich, 1972.276

Untitled (Tamarind #2192), 1968
lithograph, edition of 9 Tamarind Impressions
22 x 30 inches (55.5 x 76.2 cm)
Collection Museum of Contemporary Art, San Diego,
Gift of Mr. and Mrs. Martin L. Gleich, 1972.275

Untitled (Tamarind #2193), 1968
lithograph, edition of 9 Tamarind Impressions
22 3/8 x 30 1/8 inches (57 x 76.4 cm)
Collection Museum of Contemporary Art, San Diego,
Gift of Mr. and Mrs. Martin L. Gleich, 1972.274

Untitled (Tamarind #2113II), 1968
lithograph, edition of 9 Tamarind Impressions
22 x 30 inches (55.5 x 76 cm)
Collection Museum of Contemporary Art, San Diego,
Gift of Mr. and Mrs. Martin L. Gleich, 1972.272

Untitled (Tamarind #2222), 1968
lithograph, edition of 9 Tamarind Impressions
22 x 30 inches (55.5 x 76 cm)
Collection Museum of Contemporary Art, San Diego,
Gift of Mr. and Mrs. Martin L. Gleich, 1972.277

BORN
1925 Los Angeles, California
DIED
1969 Los Angeles, California

EDUCATION
1950 Chouinard Art Institute, Los Angeles, California
1949-50 Art Center, Los Angeles, California
1947-49 Otis Art Institute, Los Angeles, California

SOLO EXHIBITIONS
1997 • Museum of Contemporary Art, San Diego,
California. Catalogue. Text by Hugh M. Davies,
Andrea Hales, Dr. Milton Wexler, Peter Selz, and
Robert Creeley.
1994 • Braunstein/Quay Gallery, San Francisco,
California, "Abstract Works: 1960-66."
1992 • Braunstein/Quay Gallery, San Francisco,
California, "Female Nudes: 1962-66."
1991 • Dorothy Goldeen Gallery, Santa Monica,
California, "Poured Paintings."
1988 • Tortue Gallery, Santa Monica, California.
1987 • Braunstein/Quay Gallery, San Francisco,
California, "Prints."
1986 • Marianne Deson Gallery, Chicago, Illinois.
1985 • Edward Thorp Gallery, New York, New York,
"12 Paintings." Catalogue. Text by Jay Belloli.
Traveled to Tortue Gallery, Santa Monica, California,
and Braunstein Gallery, San Francisco, California.
1984 • Baxter Art Gallery, California Institute of
Technology, Pasadena, "John Altoon: 25 Paintings,
1957-1969." Catalogue. Text by Jay Belloli.
• The Arts Club of Chicago, Illinois, "John Altoon,
Works on Paper." Catalogue. Text by Gerald
Nordland. Traveled to Nelson Fine Arts Center at
Matthews Center, Arizona State University, Tempe;
Huntsville Museum of Art, Alabama; Museum of
Fine Arts, University of Utah, Salt Lake City;
Krannert Art Museum, University of Illinois,
Champaign/Urbana.
• Edward Thorp Gallery, New York, New York.
1983 • Fine Arts Gallery, University of Nevada, Las Vegas,
"Drawings 1964-66."
• Edward Thorp Gallery, New York, New York.
1982 • The Faith & Charity In Hope Gallery, Hope, Idaho,
"John Altoon." Catalogue. Text by Edward Kienholz.
• Tortue Gallery, Santa Monica, California,
"John Altoon: Paintings and Drawings, 1962-1968."
• Edward Thorp Gallery, New York, New York.
• Riverside Art Center & Museum, California.
• Fine Arts Gallery, University of Nevada, Las Vegas.
1981 • University Art Museum, University of California,
Santa Barbara.
• Braunstein Gallery, San Francisco, California,
"John Altoon: Advertising Satire Series."
• California State University, Fullerton, "Altoon."
1980 • Morgan Gallery, Kansas City, Missouri, "Drawings."
• De Saisset Museum, University of Santa Clara,
California. Catalogue. Text by Brigid Barton and
Gerald Nordland.
1979 • Braunstein Gallery, San Francisco, California,
"John Altoon: Drawings."
• Edward Thorp Gallery, New York, New York,
"Drawings."

- Tortue Gallery, Santa Monica, California, "John Altoon: Drawings."
- La Jolla Museum of Contemporary Art, California, "John Altoon: Drawings and Temperas."
1978 • Dorothy Rosenthal Gallery, Chicago, Illinois.
- Braunstein Gallery, San Francisco, California.
1977 • Braunstein/Quay Gallery, New York, New York.
1976 • Braunstein/Quay Gallery, San Francisco, California.
1975 • Seder/Creigh Gallery, Coronado, California.
- Nicholas Wilder Gallery, Los Angeles, California.
1974 • E.B. Crocker Art Gallery, Sacramento, California, "John Altoon: An Exhibition of Paintings, Drawings and Prints." Catalogue.
1973 • Newport Harbor Art Museum, Newport Beach, California, "John Altoon (1925-1969)."
- Felicity Samuels Gallery, London, England.
- San Jose State University Gallery, California.
- Quay Gallery, San Francisco, California.
1972 • Tibor de Nagy Gallery, New York, New York, "John Altoon: Drawings."
- Galerie Hans R. Neuendorf, Cologne, West Germany.
- Georgia Museum of Art, University of Georgia, Athens.
1971 • Whitney Museum of American Art, New York, New York, "John Altoon – Drawings and Prints." Catalogue. Text by Walter Hopps and Elke M. Solomon. Traveled to Corcoran Gallery of Art, Washington, D.C.
- Tibor de Nagy Gallery, New York, New York, "Cowboys and Indians."
- Quay Gallery, San Francisco, California, "John Altoon – Drawings and Prints."
1969 • La Jolla Museum of Art, California, "John Altoon Memorial Exhibition."
1968 • David Stuart Galleries, Los Angeles, California, "Drawings."
- Quay Gallery, San Francisco, California, "The Princess & the Frog Series" and "Cowboys & Indians Series."
1967 • Stanford Art Gallery, Stanford University, Palo Alto, California, "John Altoon: Recent Watercolors."
- David Stuart Galleries, Los Angeles, California.
- San Francisco Museum of Art, California, "John Altoon." Catalogue. Text by Gerald Nordland. Traveled to Pasadena Art Museum, California, and Art Gallery, University of California, San Diego, in 1968.
1966 • Fischbach Gallery, New York, New York.
- Quay Gallery, San Francisco, California,
- David Stuart Galleries, Los Angeles, California, "John Altoon: Drawings."
1965 • Hack-Light Gallery, Phoenix, Arizona.
- David Stuart Galleries, Los Angeles, California.
- Santa Barbara Museum of Art, California.
1964 • David Stuart Galleries, Los Angeles, California.
1963 • M.H. de Young Museum, San Francisco, California.
1962 • Ferus Gallery, Los Angeles, California, "John Altoon: Ocean Park Series."
1961 • Ferus Gallery, Los Angeles, California.
1960 • The Art Center in La Jolla, California.
1958 • Ferus Gallery, Los Angeles, California, "John Altoon: Paintings 1958."
1954 • Ganso Gallery, New York, New York.
1953 • Artists' Gallery, New York, New York.
1951 • Santa Barbara Museum of Art, California.

SELECTED GROUP EXHIBITIONS

1997 • Louisiana Museum of Art, Humlebaek, Denmark, "Sunshine & Noir: Art in L.A. 1960-1997." Catalogue. Traveled to Kunstmuseum, Wolfsburg, Germany; Castello di Rivoli, Museo d'Arte Contemporanea, Torino, Italy; Armand Hammer Museum of Art and Cultural Center, University of California, Los Angeles.

1995-96 • Contemporary Artists Collective/Temporary Contemporary, Las Vegas, Nevada, and Armory Center for the Arts, Pasadena, California, "Sexy, Sensual Abstraction in California Art, 1950s-1990s."
1994 • Shasta College Gallery, Redding, California, "Braunstein/Quay Gallery Artists."
1993 • Cypress College Airbrush Invitational, California.
1990 • Nagoya City Art Museum, Japan, "Abstract Painting on the West Coast." Catalogue. Traveled to the Museum of Modern Art, Shiga, Japan, and the Hara Museum, Tokyo, Japan.
- Braunstein/Quay Gallery, San Francisco, California, "Bay Area Sculptors of the 1960s: Then and Now."
1985 • De Saisset Museum, Santa Clara, California, "New Acquisitions."
1984 • Edward Thorp Gallery, New York, New York.
1983-84 • The Museum of Contemporary Art, Los Angeles, California, "The First Show."
1983 • Edward Thorp Gallery, New York, New York.
1982 • Edward Thorp Gallery, New York, New York.
1981 • Braunstein Gallery, San Francisco, California, "20th Anniversary Exhibition." Catalogue.
- Art Department, San Jose State University, California, "The Artist and the Airbrush."
- Edward Thorp Gallery, New York, New York.
1979 • Braunstein Gallery, San Francisco, California.
- Tibor de Nagy Gallery, New York, New York.
1978 • Dorothy Rosenthal Gallery, Chicago, Illinois.
1977 • San Francisco Museum of Modern Art, California, "Painting and Sculpture in California." Catalogue. Text by Henry T. Hopkins. Traveled to National Collection of Fine Arts, Smithsonian Institution, Washington, D.C.
1976 • California State University, Northridge, "A Collection Without Walls." Catalogue. Introduction by Jean-Luc Bordeaux.
- Newport Harbor Art Museum, Newport Beach, California, "The Last Time I Saw Ferus 1957-1966." Catalogue. Text by Betty Turnbull.
- Braunstein/Quay Gallery, New York, New York.
1975 • Newport Harbor Art Museum, Newport Beach, California, "A Drawing Show."
- Linda Farris Gallery, Seattle, Washington, "Images of Women."
- Art Gallery, Santa Monica College, California, "Four Santa Monica Artists: John Altoon, Richard Diebenkorn, Sam Francis, Stanton MacDonald-Wright."
1974 • Quay Gallery, San Francisco, California, "Drawings."
- Polly Friedlander Gallery, Seattle, Washington, "Erotic Works: John Altoon, Alden Mason, Ralph Corners."
- National Collection of Fine Arts, Smithsonian Institution, Washington, D.C., "Eight from California." Catalogue. Text by Janet A. Flint.
1973 • Claremont College, California, "Quay Gallery Group."
- Whitney Museum of American Art, New York, New York, "American Drawings 1963-1973." Catalogue. Text by Elke M. Solomon.
1971 • Hayward Gallery, London, England, "Eleven Los Angeles Artists." Catalogue. Text by Maurice Tuchman and Jane Livingston.
- Santa Barbara Museum of Art, California, "Spray." Catalogue. Text by Paul C. Mills.
- David Stuart Galleries, Los Angeles, California, "John Altoon, Mel Ramos: Lithographs."
1969 • Krannert Art Museum, University of Illinois at Champaign/Urbana, "Contemporary American Painting and Sculpture." Catalogue. Text by James R. Shipley and Allen S. Weller.
1968 • David Stuart Galleries, Los Angeles, California,

"Tamarind Lithographs."
- Los Angeles County Museum of Art, California, "Late Fifties at Ferus." Catalogue. Text by James Monte.
1967-68 • Tokyo, Japan, "Fourth International Young Artists' Exhibition." Catalogue.
1967 • Henry Art Gallery, University of Washington, Seattle, "Drawings by Americans." Catalogue.
- University of Colorado, Boulder, "N.Y. – L.A. Drawings of the Sixties." Catalogue. Text by Jan Von Adlmann. Traveled to Art Museum, University of New Mexico, Albuquerque.
1966 • University of Texas, Austin, "Drawings &." Catalogue.
- David Stuart Galleries, Los Angeles, California.
1964 • San Francisco Museum of Art, California.
- The Art Center in La Jolla, California, "Fourth Annual of California Painting and Sculpture."
- Solomon R. Guggenheim Museum, New York, New York, "American Drawing." Catalogue.
- David Stuart Galleries, Los Angeles, California.
- Quay Gallery, Tiburon, California.
1963 • Ferus Gallery, Los Angeles, California.
1962 • Santa Barbara Museum of Art, California, "Pacific Coast Invitational." Catalogue. Traveled to the Fine Arts Gallery of San Diego, California; Municipal Art Gallery, Los Angeles, California; San Francisco Museum of Art, California; Seattle Art Museum, Washington; Portland Art Museum, Oregon.
- Whitney Museum of American Art, New York, New York, "Fifty California Artists." Catalogue. Traveled to the Walker Art Center, Minneapolis, Minnesota; Albright-Knox Art Gallery, Buffalo, New York; Des Moines Art Center, Iowa. Organized by the San Francisco Museum of Art with the assistance of the Los Angeles County Museum, California.
1961 • Los Angeles County Museum, California, "Annual Exhibition of Artists of Los Angeles County and Vicinity." Catalogue.
- Ferus Gallery, Los Angeles, California, "Drawings and Gouaches by John Altoon and Richards Ruben."
- Ferus Gallery, Los Angeles, California.
1960 • Los Angeles County Museum, California, "Annual Exhibition of Artists of Los Angeles County and Vicinity." Catalogue.
- Ferus Gallery, Los Angeles, California.
1959 • Los Angeles County Museum, California, "Annual Exhibition of Artists of Los Angeles County and Vicinity." Catalogue.
- Carnegie Institute, Pittsburgh, Pennsylvania.
- Ferus Gallery, Los Angeles, California, "John Altoon, Gouaches; Sonia Gechtoff, Recent Drawings."
- Ferus Gallery, Los Angeles, California.
1958 • Ferus Gallery, Los Angeles, California.
- Los Angeles County Museum, California, "Annual Exhibition of Artists of Los Angeles County and Vicinity." Catalogue.
1957 • Ferus Gallery, Los Angeles, California, "Objects on the New Landscape Demanding of the Eye."

COLLECTIONS

Art Institute of Chicago, Illinois
Fine Arts Museums of San Francisco
Fine Arts Museum, University of Utah, Salt Lake City
Levi-Strauss Collection, San Francisco, California
Los Angeles County Museum of Art, California
The Museum of Contemporary Art, Los Angeles
Museum of Contemporary Art, San Diego
The Museum of Modern Art, New York
Norton Simon Museum, Pasadena, California
Oakland Museum of Art, California
Orange County Museum of Art, Newport Beach

San Diego Museum of Art
San Francisco Museum of Modern Art, California
Stanford University Art Galleries, California
University of California, Berkeley Art Museum
Whitney Museum of American Art, New York

SELECTED BIBLIOGRAPHY

CATALOGUES – SOLO EXHIBITIONS

- San Francisco Museum of Art. *John Altoon*. San Francisco, 1967. (Text by Gerald Nordland; ill. cover, p. 7, 9, 16-19, 21-25.)
- Whitney Museum of American Art. *John Altoon - Drawings and Prints*. New York, 1971. (Text by Walter Hopps and Elke M. Solomon; ill. cover, p. 6, 9, 11-22.)
- E. B. Crocker Art Gallery. *John Altoon – An Exhibition of Paintings, Drawings and Prints*. Sacramento, 1974.
- De Saisset Museum, University of Santa Clara. *John Altoon*. Santa Clara, 1980. (Text by Brigid S. Barton; ill. cover, p. 2, 11-12, 17, 20-33, 37, 39.)
- The Faith and Charity in Hope Gallery. *John Altoon*. Hope, Idaho, 1982. (Text by Edward Kienholz; ill. cover, p. 4-16.)
- The Arts Club of Chicago. *John Altoon, Works on Paper*. Chicago, 1984. (Text by Gerald Nordland; ill. cover, p. 7-14.)
- Baxter Art Gallery, California Institute of Technology. *John Altoon – 25 Paintings, 1957-1969*. Pasadena, 1984. (Text by Jay Belloli; ill. cover, p. 5-6, 9, 11, 13-14, 17, 27, 29, 31-32.)
- Braunstein/Quay Gallery. *John Altoon 12 Paintings*. San Francisco, 1985. (Text by Jay Belloli; ill. cover, p. 1-2, 5-15.) Traveled to Edward Thorp Gallery, New York, and Tortue Gallery, Santa Monica.
- Museum of Contemporary Art, San Diego. *John Altoon*. La Jolla, California, 1997. (Text by Hugh M. Davies, Andrea Hales, Dr. Milton Wexler, Peter Selz, and Robert Creeley; ill. cover, p. 17-50)

CATALOGUES – GROUP EXHIBITIONS

- Los Angeles County Museum. *1958 Annual Exhibition of Artists of Los Angeles and Vicinity*. Los Angeles, 1958.
- Los Angeles County Museum. *1959 Annual Exhibition of Artists of Los Angeles and Vicinity*. Los Angeles, 1959. (ill. p. 10, 24.)
- Los Angeles County Museum. *1960 Annual Exhibition of Artists of Los Angeles and Vicinity*. Los Angeles, 1960. (ill. p. 14.)
- Los Angeles County Museum. *1961 Annual Exhibition of Artists of Los Angeles and Vicinity*. Los Angeles, 1961. (ill. p. 8, Junior Art Council Prize and Purchase Award.)
- Whitney Museum of American Art. *Fifty California Artists*. Organized by San Francisco Museum of Art with Los Angeles County Museum for the Whitney Museum of American Art, Walker Art Center, Albright-Knox Art Gallery, and Des Moines Art Center. 1962. (ill. p. 15.)
- Santa Barbara Museum of Art. *Pacific Coast Invitational*. Santa Barbara, 1962. (ill. p. 8.)
- The Solomon R. Guggenheim Museum. *American Drawings*. New York, 1964.
- University of Texas, University Art Museum. *Drawings &*. Austin, 1966.
- University of Washington, Henry Art Gallery. *Drawings by Americans*. Seattle, 1967. (ill. p. 7-9.)
- *Fourth International Young Artists' Exhibition*. Tokyo, Japan, 1967. (ill. p. 10, International Young Artists' Exhibition Award, Congress for Cultural Freedom Award.)
- University of Colorado, Boulder, and University Art Museum of New Mexico, Albuquerque. *N.Y. – L.A. Drawings of the Sixties*. 1967. (Text by Jan Von Adlmann.)
- Los Angeles County Museum of Art. *Late Fifties at the Ferus*. Los Angeles, 1968. (Text by James Monte.)

• Krannert Art Museum. *Contemporary American Painting and Sculpture*. University of Illinois at Champaign/Urbana, 1969. (Text by James R. Shipley and Allen S. Weller.)

• Arts Council of Great Britain, Hayward Gallery. *Eleven Los Angeles Artists*. London, 1971. (Text by Maurice Tuchman and Jane Livingston.)

• Santa Barbara Museum of Art. *Spray*. Santa Barbara, 1971. (Text by Paul C. Mills.)

• Whitney Museum of American Art. *American Drawings 1963-1973*. New York, 1973. (Text by Elke M. Solomon.)

• National Collection of Fine Arts, Smithsonian Institution. *Eight from California*. Washington, D. C., 1974. (Text by Janet A. Flint.)

• California State University, Northridge. *A Collection Without Walls*. Northridge, 1976. (Intro. by Jean Luc Bordeaux; ill. p. 4.)

• Newport Harbor Art Museum. *The Last Time I Saw Ferus 1957-1966*. Newport Harbor, 1976. (Text by Betty Turnbull.)

• San Francisco Museum of Modern Art. *Painting and Sculpture in California: The Modern Era*. San Francisco, 1977. (Introduction and preface by Henry T. Hopkins; ill. p. 142.) Exhibition traveled to National Collection of Fine Arts, Smithsonian Institution, Washington, D. C.

• Nagoya City Art Museum. *Abstract Painting on the West Coast*. Nagoya, Japan 1990. (Text by Noriko Fujinami.) Exhibition traveled to Museum of Modern Art, Shiga, Japan, and the Hara Museum, Tokyo, Japan.

• Louisiana Museum of Modern Art. *Sunshine & Noir: Art in L.A. 1960-1997*. Humlebaek, Denmark, 1997. Exhibition traveled to Kunstmuseum Wolfsburg, Germany; Castello di Rivoli, Museo d'Arte Contemporanea, Torino, Italy; Armand Hammer Museum of Art and Cultural Center, University of California, Los Angeles. (ill. album 4 and 5.)

PERIODICALS

1953 • Guest, Barbara. "Reviews and Previews, John Altoon." *ARTnews* (New York) 52, no. 8 (December): 45.
• F. S. L. "John Altoon." *Arts Digest* (New York) 28, no. 5 (December 1): 22 (ill. – *Tired, Skinny and Mean.*)

1954 • V. C. "John Altoon." *Arts Digest* (New York) 29, no. 5 (December 1): 26.

1955 • Tyler, Parker. "John Altoon: Ganso." *ARTnews* (New York) 53, no. 9 (January): 51.

1958 • Langsner, Jules. "Art News From Los Angeles." *ARTnews* (New York) 57, no. 6 (October): 44 (ill. – *Untitled.*)
• Nordland, Gerald. "Art: John Altoon." *Frontier* (Los Angeles), October: 24-25 (ill.).

1959 • Nordland, Gerald. "Art: At the County Museum." *Frontier* (Los Angeles) 10, no. 11 (September): 23-25 (ill.).

1960 • Nordland, Gerald. "The All-California Show." *San Diego* (San Diego, California), December: 74-75, 120 (ill.)

1961 • Nordland, Gerald. "Altoon: A Scrupulous Draftsman." *Los Angeles Mirror* (Los Angeles) part 3 (January 23): 4.
• Nordland, Gerald. "Variety and Expansion." *Arts Magazine* (New York) 36, no. 2 (November): 48-50 (ill. – untitled drawing, 1961.)

1962 • Langsner, Jules. "Art News From Los Angeles." *ARTnews* (New York) 60, no. 9 (January): 52 (ill. – *Untitled.*)
• Nordland, Gerald. "Los Angeles Overture." *Arts Magazine* (New York) 37, no. 1 (October): 46.

1963 • Bogat, Regina. "Fifty California Artists." *Artforum*

(New York) 1, no. 7 (January): 23-26.
• McClellan, Douglas. "John Altoon, Ferus Gallery." *Artforum* (New York) 1, no. 7 (January): 20.
• Smith, Vic. "The Pacific Coast Invitational." *Artforum* (New York) 1, no. 8 (February): 8-10 (ill.)
• Frankenstein, Alfred. "Altoon's Infantile, Gaga Abstractions." *San Francisco Examiner* (San Francisco), March 10: 5.
• Langsner, Jules. "Art Centers, Los Angeles: America's Second Art City." *Art in America* (New York) 51 (April): 127-131. (ill. only – *Ocean Park Series No. 5.*)
• Monte, James. "John Altoon, De Young Museum." *Artforum* (New York) 1, no. 2 (May): 13.

1964 • Reuschel, John. "Fourth Annual of California Painting and Sculpture – The Art Center in La Jolla." *Artforum* (New York) 2, no. 7 (January): 43.
• "John Altoon: Four Drawings." *Artforum* (New York) 2, no. 8 (February): 30-31 (ill. only – untitled drawing 1961, 3 - untitled drawings 1963.)
• Seldis, Henry J. "In the Galleries: Altoon Expands Pop Art Horizons." *Los Angeles Times* (Los Angeles) part 4 (May 18): 6.
• Hopkins, Henry T. "Abstract Expressionism." *Artforum* (New York) 2, no. 12 (Summer): 59 (ill.)

1965 • Perkins, Constance. "In the Galleries: Altoon Imagery Provides Window on Subconscious." *Los Angeles Times* (Los Angeles), February 5: 4.
• Factor, Don. "John Altoon, David Stuart Gallery." *Artforum* (New York) 3, no. 6 (March): 12 (ill. – *Seaview Series No. 3*, 1964.)
• Seldis, Henry J. "West Coast Milestone." *Art in America* (New York) 53 (April): 108 (ill. – *Ocean Park Series No. 2*, ca. 1960.)
• Marmer, Nancy. "Los Angeles Letter." *Art International* (Switzerland) 9, no. 4 (May): 44-45 (ill.)

1966 • Frankenstein, Alfred. "Around the Art Galleries." *San Francisco Chronicle* (San Francisco), February 14: 52 (ill. – *Untitled*, 1965.)
• Rose, Barbara. "Los Angeles: The Second City." *Art in America* (New York) 54, no. 1 (February): 110-15 (ill.)
• Monte, James. "San Francisco." *Artforum* (New York) 4, no. 8, (April): 54-55.
• Aldrich, Larry. "New Talent USA." *Art in America* (New York) 54, no. 4 (July/August): 64 (ill. – *S & H Series.*)
• Ashbery, John. "Reviews and Previews, John Altoon." *ARTnews* (New York) 65, No. 8, (December): 8.
• Seldis, Henry. "In the Galleries: John Altoon Satirizes Man at Stuart Galleries." *Los Angeles Times* (Los Angeles) part 5 (December 16): 12.

1967 • Langsner, Jules. "Los Angeles: Cremean, Altoon." *ARTnews* (New York) 65, no. 10 (February): 57.
• Wechsler, Judith. "John Altoon's 'Harper Series'." *Artforum* (New York) 5, no. 6 (February): 52-53 (ill. – *Alice in Wonderland & the Princess*, 1966; *Harper Series #11*, 1966.)
• Carpenter, Ken. "San Francisco: John Altoon." *Artscanada* (Ontario, Canada) 107 (April): 6 (ill. – *Harper Series.*)

1968 • Seldis, Henry J. "John Altoon -- Satirist with a Sexy Streak." *Los Angeles Times* (Los Angeles), January 21 (ill. – *Satire #1*; *Sunset Series*): 38.
• Good, Jeanne. "Altoon Shows Satiric Work." *Citizen News* (Pasadena) February 2: 15.
• French, Palmer D. "John Altoon, San Francisco Museum of Art." *Artforum* (New York) 6, no. 7 (March): 67-68 (ill. – *Untitled, Princess and Frog Series*, 1968.)

• Hagberg, Marilyn. "John Altoon's Phallic Landscapes and Other Personal Pictures." *San Diego Magazine* (San Diego), April: 57, 60, 87 (ill. – *Ocean Park Series #11*, 1962; *The Tattooed Lady*, 1964; *Satire #1*, 1966.)
• Hoag, Jane. "Los Angeles: John Altoon." *ARTnews* (New York) 67, no. 2, (April): 23.
• Terbell, Melinda. "West Coast Shows: John Altoon." *Arts Magazine* (New York) 42, no. 7 (May): 61.
• Seldis, Henry. "Otis Institute Alumni Show Marks 50th Anniversary." *Los Angeles Times* (Los Angeles), September 22: 52 (ill. – *Harper Series.*)
• Frankenstein, Alfred. "Four West Coast Artists." *San Francisco Chronicle* (San Francisco), October 10: 47.

1969 • Bengston, Billy Al. "Late Fifties at The Ferus." *Artforum* (New York) 7, no. 5 (January): 33-35.
• French, Palmer D. "San Francisco." *Artforum* (New York) 7, no. 5 (January): 66-68 (ill. – *Untitled, Princess and Frog Series*, 1968.)
• Livingston, Jane. "Two Generations in L.A." *Art in America* (New York) 57 (January-February): 92-97 (ill. – *Untitled*, 1968.)

1971 • Levin, Kim. "Reviews and Previews: John Altoon." *ARTnews* (New York) 69, no. 9 (January): 16.
• Domingo, Willis. *Arts Magazine* (New York) 45, no. 4 (February): 58.
• Linville, Kasha. "New York." *Artforum* (New York) 9, no. 6 (February): 82 (ill. – *C/1-31.*)
• Albright, Thomas. "Altoon's Masterful Art at Quay." *San Francisco Chronicle* (San Francisco), April 29.
• McCann, Cecil. "Altoon Paintings." *Artweek* (California), May 15: 2.
• *ARTnews* (New York) 70, no. 5 (September): 32 (ill. only – *ANI.70 (Sharks)*, 1967.)
• Campbell, Lawrence. "John Altoon: Whitney Museum." *ARTnews* (New York) 70, no. 8 (December): 12.
• Frackman, Noel. "Altoon at the Whitney." *Arts Magazine* (New York) 46, no. 3 (December/January 1972): 56-57.

1972 • Ratcliff, Carter. "New York Letter." *Art International* (Switzerland) 16, no. 1 (January 20): 69.

1973 • Catoir, Barbara. "John Altoon." *Das Kunstwerk* (Stuttgart, Germany) 26 (January): 67.
• Dunham, Judith. "Altoon's Objects." *Artweek* (California) 4, no. 12 (March 24): 5.
• Kingsley, April. "New York Letter." *Art International* (Switzerland) 17 (March): 74.
• Whittet, G. S. "London." *Art and Artists* (London) 8, no. 1 (April): 49.
• Tarshis, Jerome. "San Francisco." *ARTnews* (New York) 72, no. 5 (May): 47.
• Fuller, Peter. "John Altoon 1925-69." *Connoisseur* (London) 183 (June): 158. (ill. – *F-1967-3.*)
• Seldis, Henry J. "Visual Memories of a Fertile Fantasy." *Los Angeles Times* (Los Angeles), November 25 (ill.)

1974 • "John Altoon Tip Trio Series." *Artweek* (California) 5, no. 5 (February 2): 2.
• Hart, Jean. "Erotic Art by Three West Coast Artists." *Artweek* (California) 5, no. 16 (April 20): 13.

1975 • Wortz, Melinda. "Drawings by California Artists." *Artweek* (California) 6, no. 7 (February 15): 1.
• Hackett, Regina. "Woman's Many Facets." *Artweek* (California) 6, no. 41 (November 29): 13.

1976 • Dunham, Judith. "John Altoon: Object Series 22." *Artweek* (California) 7, no. 12 (March 20): 71 (ill.)

• Askey, Ruth. "The Ferus Gallery Remembered." *Artweek* (California) 7, no. 14 (April 3): 5.
• Albright, Thomas. "Altoon's Masterful Art at Quay." *San Francisco Chronicle* (San Francisco), April 29.

1977 • "John Altoon." *New York Times* (New York), November 4.
• Frank, Peter. "Pictures as an Exhibition." *Village Voice* (New York) November 7: 75.

1978 • Burnside, Madeleine. "John Altoon (Braunstein/Quay)." *ARTnews* (New York) 77, no. 1 (January): 144.

1979 • French, Palmer D. "Incomplete Altoon: Braunstein Gallery, San Francisco." *Artweek* (California) 10, no. 3 (April 28): 3 (ill.)
• Glueck, Grace. "John Altoon: Edward Thorp Gallery." *New York Times* (New York), September 21.
• Muchnic, Suzanne. "John Altoon: Tortue Gallery." *Los Angeles* (Los Angeles), October 19.

1980 • Magid, Debra. "John Altoon." *Arts Magazine* (New York) 54, (January): 11 (ill. – *Untitled (ABS-35-1965.)*
• Temko, Allan. "John Altoon Retrospective." *San Francisco Sunday Examiner and Chronicle* (San Francisco), November 7:15.
• Dunham, Judith L. "John Altoon – A Comprehensive Look." *Artweek* (California) 11 (November 22): 1 & 16 (ill. – *Early '66, Untitled (Satire #4)*, 1967, *Untitled (ABS J-115)*, 1966, *Ocean Park Series #11*, 1962.)

1984 • Knight, Christopher. "John Altoon Was Never an Artist of His Own Time." *Los Angeles Herald* (Los Angeles) May 6.
• Artner, Alan G. "John Altoon: Arts Club." *Chicago Tribune* (Chicago) Section 5 (June 1): 18.
• Ewing, Robert. "John Altoon: No Verdict Yet." *Artweek* (California) 15 (June 30): 1 (ill. – *Untitled*, 1967, *Untitled*, 1956-7, *Sunset Series Untitled*, 1965.)

1985 • Brenson, Michael. "Art: Works by a Figure of the Counterculture." *New York Times* (New York) Section C (January 25) 24.
• Yau, John. "John Altoon: Edward Thorp Gallery." *Artforum* (New York) 23 (March): 93-4 (ill. – *Haircut #2.*)

1988 • Spiegel, Judith. "Out of a Rollicking Time." *Artweek* (California)19, no. 44 (December 24): 5 (ill. – *Untitled* 1965.)

1991 • Gottlieb, Shirle. "Dancing Through Space: John Altoon at Dorothy Goldeen Gallery." *Artweek* (California) 22, no. 4 (January 31): 14-15 (ill. – *Untitled.*)

1992 • Baker, Kenneth. "Last Chance to Catch Up With Some Shows." *San Francisco Chronicle* (San Francisco), February 29: 65.
• Schipper, Merle. "John Altoon." *AIM* (August/September): 76.

1993 • Muchnic, Suzanne. "Norton Simon Museum to Spotlight Altoon." *Los Angeles Times* (Los Angeles), March 17.

NOTES

CHRONOLOGY OF AN ARTIST ANDREA HALES

1. Artist Robert Irwin, three years younger than Altoon, who later became part of the Ferus stable of artists, also attended Dorsey High School.

2. The Anna Lee Stacey Award. Altoon later won the Junior Art Council Prize and Purchase Prize Award for an ink drawing from the Los Angeles County Museum in 1961; a Copley Foundation Award from New York in 1964; an award from the Instituto de Cultura Hispanica from Madrid in 1964 (which he had to forfeit); and in 1968, a $5,000 Atlantic Richfield Corporation Purchase Prize for a *Harper* series painting.

3. Among The Artists' Gallery papers, which are housed at the Smithsonian Institution's Archives of American Art, are exhibition price lists from Altoon's 1953 exhibition that enumerate the artist's accomplishments, including exhibitions and awards won.

4. The Artists' Gallery December 1953 exhibition consisted of twenty-one paintings. Paintings that were sold include: *The City, Chickens, Turkish Coffee Shop, Androcles and the Lion*, and *Beach Day Endings*. Reviews of the exhibition appeared in *The New York Times* (December 19, 1953), *ARTnews*, and *Art Digest*.

5. Robert Creeley, interview by Kevin Power, 1977, *Robert Creeley's Life and Work*, edited by John Wilson (Ann Arbor: The University of Michigan Press, 1987) 359.

6. Altoon also taught at the University of California, Los Angeles and Chouinard Art Institute in 1962-63 and at the Pasadena Art Museum in 1965-66. From David Stuart Galleries papers at the Archives of American Art.

7. The opening exhibition of the Ferus Gallery at 736A North La Cienega Boulevard was held from March 15 through April 11, 1957. The exhibition was titled "Objects on the New Landscape Demanding of the Eye" and included: John Altoon, Billy Al Bengston, Jay DeFeo, Roy De Forest, Richard Diebenkorn, James Budd Dixon, Sonia Gechtoff, (?) Henderson, Ellsworth Kelly, Craig Kauffman,(?) Johnson, Edward Kienholz, Frank Lobdell, Edward Moses, Hassel Smith, Clyfford Still, and Julius Wasserstein.

8. Altoon's exhibitions at Ferus Gallery are listed as: March 15 - April 11, 1957 (group); "Drawings," July 19 - August 15, 1957 (one-person); December 6, 1957 - January 4, 1958 (group); January 6 - January 31, 1958 (Altoon, Kienholz, DeFeo); May 9 - May 31, 1958 (group); October 10 - November 6, 1958 (one-person); November - December 1958 (opening of the "new" Ferus at 723 North La Cienega Boulevard; group); July 20 - August 15, 1959 (group); "Gouaches," November 9 - December 5, 1959 (with Sonia Gechtoff, "Drawings"); June 20 - July 16, 1960 (group); January 9 - February 11, 1961 (one-person); April 3 - April 29, 1961 (group); September 18 - October 14, 1961 (one-person; Richards Ruben, one-person); October 15 - November 10, 1962 (one-person); June - July, 1963 (group). From *The Last Time I Saw Ferus: 1957 - 1966*, exhibition catalogue (Newport Beach: Newport Harbor Art Museum, 1976)

9. Craig Krull, *Photographing the L.A. Art Scene, 1955 - 1975*, exhibition catalogue (Santa Monica: Smart Art Press, 1996) 49.

10. From a conversation with Irving Blum, August 7, 1997.

11. From a conversation with Larry Bell, July 3, 1997.

12. Krull, 50.

13. Krull, 50.

14. From a conversation with Ken Price, August 15, 1997.

15. Altoon's work included in the juried exhibition, *Annual Exhibition of Artists of Los Angeles and Vicinity*, consisted of an untitled 30 x 40 inch tempera in 1958; *Trip No. 2*, an oil on canvas (p.23) and an untitled 30 x 40 inch drawing in 1959; *Trip #8*, a 92 x 65 inch oil on canvas in 1960; and an untitled 30 x 40 inch drawing in 1961 for which he received the $150 Junior Art Council Prize Award and the Junior Art Council Purchase Award.

16. "14 New York Artists" was shown from January 18 - February 3, 1960, at Ferus Gallery. Artists included were: James Brooks, Willem de Kooning, Arshile Gorky, Philip Guston, Hans Hoffman, Franz Kline, Joan Mitchell, Robert Motherwell, Louise Nevelson, Barnett Newman, Jackson Pollock, Milton Resnick, Mark Rothko, and Jack Tworkov. *The Last Time I Saw Ferus: 1957 - 1966*, exhibition catalogue (Newport Beach: Newport Harbor Art Museum, 1976)

17. Gorky, not unlike Altoon, synthesized the styles of many artists in the search for his personal vision, including Pablo Picasso during the early 1930s, and Wassily Kandinsky and Matta beginning in 1936, when Gorky turned away from figurative work and moved toward biomorphic abstraction. A connection with Surrealists Matta and André Breton, together with the work of Joan Miró, finally helped to enable Gorky's personal imagery.

18. Sandler, Irving Sandler, *The Triumph of American Painting: A History of Abstract Expressionism* (New York: Harper & Row, 1970) 54.

19. A description of the exhibition, which ran from November 19 through December 4, 1960, is: "Non-objective paintings by Los Angeles artist, John Altoon, in the One-Man Show Gallery." From MCA archives.

20. The "First Annual Painting and Sculpture Exhibit," was an exhibition of California artists juried by H.H. Arnason and ran from November 15, 1959 through January 1, 1960.

21. There were originally eighteen in the *Ocean Park* series, but many were destroyed by Altoon; four are included in this exhibition. Beginning with the Ocean Park series, Altoon began identifying canvases according to the location of his studio, a practice that has led to confusion in dating the work.

22. The *Ocean Park* series paintings were included in the "Fifty California Artists" exhibition at the Whitney Museum in New York and in the "Pacific Coast Invitational" exhibition organized by the Santa Barbara Museum of Art that traveled on the West Coast in 1962-63. In October 1962 the work was shown at Ferus Gallery and in March 1963 at the De Young Memorial Museum in San Francisco (seven oils and five drawings). Gerald Nordland, *John Altoon* exhibition catalogue (San Francisco: San Francisco Museum Art, 1967) 11.

23. Altoon was familiar with Pablo Picasso's erotic drawings. From a conversation with Ken Price, August 15, 1997.

24. Altoon, who was well versed in commercial work, hired the young Edward Ruscha, who had his first exhibition at Ferus Gallery in 1963, to produce the lettering in this drawing, as well as on four or five other illustration boards. From a conversation with Edward Ruscha, August 1997.

25. Ironically, since the 1960s, as women have gained more equity with men and feminism has become more pervasive throughout society (rather than a fledgling political movement as it was then), so has advertising — and the use of women's bodies to sell products — become increasingly more explicit and widespread.

26. Hall, James, *Dictionary of Subjects and Symbols in Art* (New York: Harper & Row, 1974) 291.

27. Hall, 318.

28. Nordland, 12.

29. Altoon made, between April 28 and May 18, 1965, a series of six prints at Tamarind Lithography Workshop, then located in Los Angeles. Each print measures approximately 57 x 76 inches. The artist's experimentation with various printing techniques is evident when comparing these six prints. Using the same lithographic stone from two black and white prints, Altoon has made a second set of prints, yet has added color. The results echo Altoon's achievement with airbrush.

30. After Altoon left Ferus Gallery, he was included in group (1964, 1965, 1966) and one-person (1964, 1965, 1967, 1968) exhibitions at the David Stuart Galleries. The David Stuart Galleries, like the Ferus Gallery, were located on North La Cienega Boulevard (David Stuart at 807 La Cienega). Their letterhead describes them as dealing in "contemporary & primitive works of art." From Archives of American Art material. David Stuart collected pre-Columbian art, much of which contains erotic overtones. Altoon also exhibited at the Quay Gallery, beginning with a group exhibition in 1964 when the gallery was in Tiburon, California, followed by one-person exhibitions in San Francisco in 1966 and 1968. Ruth Braunstein, owner of Braunstein/Quay Gallery, has continued to exhibit Altoon after his death (1971, 1973, 1976, 1977, 1979, 1981, 1987, 1992, 1994) and represents his estate.

31. According to Ken Price, Altoon's experimentation with line stemmed from looking at the linear qualities in the work of Picasso. From a conversation with Ken Price, August 15, 1997.

32. The prints were made between September 1965 to February 1966. Eight of the prints measure 19 x 19 inches; two measure 19 x 38 inches.

33. These non-narrative compositions may also be seen in canvases from the *Sunset* series of 1965-66. Yet, their simplicity on canvas in an enlarged scale is not as successful as the works are in the smaller, more detailed, linear lithographic medium.

34. From an interview with Roberta L. Thomson, Los Angeles, March 7, 1997.

35. Altoon and his wife, Babs, spent approximately six months in Europe in 1967. During that time he did not work, other than a few sketches. From an interview with Roberta L. Thomson, Los Angeles, March 7, 1997.

36. Each lithograph measures 22 x 30 inches. They were made between January 5 and February 26, 1968.

37. From a copy of the exhibition checklist copied from the David Stuart papers housed at the Archives of American Art, Washington, D.C.

38. *John Altoon*, exhibition catalogue (Santa Clara: DeSaisset Museum, University of Santa Clara, 1980) 16.

JOHN ALTOON RECONSIDERED PETER SELZ

1. Hopps, Walter. *John Altoon-Drawings and Prints*, exhibition catalogue (New York: Whitney Museum of American Art, 1971) 1.

2. Temko, Allan. "John Altoon Retrospective." *San Francisco Sunday Examiner and Chronicle* (San Francisco), November 7, 1980:15.

3. Guest, Barbara. "Reviews and Previews: John Altoon." *ARTnews* (New York) 52, no. 8 (December 1953): 45.

4. When Richard Diebenkorn moved his studio into Ocean Park Boulevard in 1968, he also entitled his paintings for the next twenty years "Ocean Park." Altoon did not remain on that street very long, and as he moved he continued naming paintings according to his addresses: *Hyperion* series 1963-64, *Sunset* series 1964-65, *Harper* series 1966-68.

ACKNOWLEDGMENTS

We have been able to present this exhibition and catalogue thanks to the support of many individuals and institutions. First and foremost, we must acknowledge the very generous contributions of Elizabeth and L.J. Cella, whose support began a number of years ago; and AFFMA (Arpa Foundation for Film, Music & Art), a private foundation dedicated to expanding appreciation of artists of Armenian descent. We also thank the National Endowment for the Arts for a major grant in support of this project. The NEA continues to be a significant factor in preserving and celebrating the cultural legacy of the United States through projects such as this one, and we are very grateful.

As with every exhibition at MCA, the contributing efforts of the entire staff are appreciated. However, I am particularly indebted to Hugh Davies for his initiative, incisive guidance and constant collegial support throughout the exhibition planning and development. Former associate curator Kathryn Kanjo deserves much credit for her preliminary research for the exhibition. I am grateful to Virginia Abblitt, Julie Dunn, Arline Hales, and especially Anne Farrell, for their careful and skilled editing of the manuscript. Kathlene Gusel patiently assisted with innumerable details and compiled the biography and bibliography with the help of museum interns Bettina John-Willeke and Seth Hirschenbein. Elizabeth Armstrong's advice and expertise were greatly appreciated, as was the assistance of Charles Castle, Jini Bernstein, Seonaid McArthur, Jessica O'Dwyer, Suzanne Scull, Gwendolyn Gómez, Rita Gonzalez, Jennifer Yancey, Synthia Malina, Jill Jones Mason, and Tom Flowers. As always, registrar Mary Johnson effectively coordinated loans, while preparator Drei Kiel and assistant preparator Ame Parsley, with their crew, efficiently installed the exhibition. I am especially grateful to graphic designer Richard Burritt, who is responsible for the thoughtful and elegant design of this publication.

The exhibition and this accompanying catalogue would not have been possible without the kind cooperation and generous support of the artist's widow, Roberta L. Thomson. The long-time dealer that represents Altoon's estate, Ruth Braunstein of the Braunstein/Quay Gallery in San Francisco, and her colleagues, Walter Maciel and Lisa Solomon, were always enthusiastic and extremely helpful in every aspect of the exhibition. Peter Selz and Dr. Milton Wexler, with their catalogue essays, add a great deal of insight to Altoon and his work and help make this catalogue a useful tool for future scholars. Poet and writer Robert Creeley generously allowed us to reprint his personal memoir about Altoon, written after the artist's death.

Additionally, I would like to thank all of the lenders, including MCA Trustee Murray and Ruth Gribin, who have over time given the Museum several key Altoon works, and former MCA Trustee L.J. and Elizabeth Cella, who have had a long-standing interest in the work of John Altoon. Other lenders to whom we are grateful are Louis F. D'Elia, Dennis Hopper, Mr. and Mrs. Joseph Smith, and Dr. Milton Wexler. Their impassioned dedication to Altoon's work was an inspiration. Equally supportive were the many institutions that agreed to lend their work. Special thanks to the directors and staff of these institutions: the Fine Arts Museums of San Francisco; the Los Angeles County Museum of Art; The Museum of Contemporary Art, Los Angeles; the Norton Simon Museum; the Orange County Museum of Art; the San Diego Museum of Art; the San Francisco Museum of Modern Art; the University of California, Berkeley Art Museum; and the SunAmerica Collection/Eli Broad Family Foundation. I am also grateful to Lisa Darling, Craig Tessler, and Edy Shackell.

A number of the important figures from Altoon's time were generous in sharing their thoughts and opinions about the artist and that fertile period in California's history. I am deeply indebted to Larry Bell, Jay Belloli, Irving Blum, Donald Brewer, Ronald Davis, Dennis Hopper, Robert Irwin, Gerald Nordland, and Ken Price. The photographs by William Claxton, Patricia Faure, Dennis Hopper, Malcolm Lubliner, and Edward Ruscha help capture Altoon's physical presence and their use is greatly appreciated. Craig Krull kindly helped with photography for the catalogue.

It has been a great pleasure to delve into the life and work of John Altoon, and be able to share what we've learned with others. It is our fervent hope that this exhibition and catalogue will now contribute to a greater appreciation of his legacy.

Andrea Hales